"PARADISE LOST"

DORÉ'S
ILLUSTRATIONS FOR
"PARADISE LOST"

GUSTAVE DORÉ

DOVER PUBLICATIONS, INC.
NEW YORK

BIBLIOGRAPHICAL NOTE

This Dover edition, first published in 1993, reproduces all 50 plates from *Milton's "Paradise Lost,"* illustrated by Gustave Doré, originally published by Cassell, Petter, and Galpin, London and New York, n.d. (ca. 1866). See the new Publisher's Note for further bibliographical details.

DOVER *Pictorial Archive* SERIES

This book belongs to the Dover Pictorial Archive Series. You may use the designs and illustrations for graphics and crafts applications, free and without special permission, provided that you include no more than four in the same publication or project. (For permission for additional use, please write to Dover Publications, Inc., 31 East 2nd Street, Mineola, N.Y. 11501.)

However, republication or reproduction of any illustration by any other graphic service whether it be in a book or in any other design resource is strictly prohibited.

LIBRARY OF CONGRESS CATALOGING-IN-PUBLICATION DATA

Doré, Gustave, 1832–1883.
 Doré's illustrations for "Paradise Lost." — Dover ed.
 p. cm. — (Dover pictorial archive series)
 "Reproduces all 50 plates from Milton's 'Paradise lost,' illustrated by Gustave Doré, originally published by Cassell, Petter, and Galpin, London, New York, (ca. 1866)"
—T.p. verso.
 ISBN 0-486-27719-4 (pbk.)
 1. Doré, Gustave, 1832–1883—Themes, motives. 2. Milton, John, 1608–1674.
Paradise lost—Illustrations. I. Title. II. Series.
NE650.D646A4 1993
769.92—dc20 93-1907
 CIP

Manufactured in the United States of America
Dover Publications, Inc., 31 East 2nd Street, Mineola, N.Y. 11501

PUBLISHER'S NOTE

GUSTAVE DORÉ (1832–1883), born in Alsace at Strasbourg, son of a civil engineer, was perhaps the most successful illustrator of the nineteenth century. Doré revealed his artistic bent early in childhood. His father's desire that he enter a respectable profession was ignored by his mother, who encouraged his development as an artist not only in the early years, but throughout his entire adult life. At the age of fifteen, while on a trip to Paris, Doré sold some work to Charles Philipon's new comic paper, *Le Journal pour rire*, and soon after was a regular contributor of lithographic caricatures drawn in the manner of Gavarni and Honoré Daumier. He was immediately popular, and "le gamin de génie," as Théophile Gautier called him, rapidly became celebrated. His father insisted on his completing his schooling, and there was no opportunity for an academic training in art; he snatched time for unorthodox study in the galleries of the Louvre and the streets of Paris. He was gifted with an extraordinary visual memory and learned by looking.

He soon became, with the death of his father, the chief support of his mother and two brothers, taking on all the work he could get: pictorial journalism, travel books, fiction of varying quality. Though much of his early work was topical caricature, the stinging understanding of his older contemporary Daumier was quite outside his range—he was no politician.

He started work in the year of revolutions, 1848, and it was in the reactionary period that followed, the Second Empire, that he became famous. He found life enjoyable in this society, a society so luxurious at the top and so readily accepting of him. He worked incredibly hard, earned a fortune and spent it lavishly. Doré's work of the 1850s is more energetic and vivacious than that of anyone else, full of a sense of fun, brilliant and fantastic and sometimes extremely horrid, with a streak of grotesque cruelty. His illustration of the classics began with a delightful Rabelais

(1854), and increasingly he cut down on his journalism to specialize in illustrating the world's great literature. During the 1860s he developed a special style of illustrated book, and the publications of this decade include Dante's *Divine Comedy*, the *Fables* of La Fontaine, *Don Quixote*, Perrault's *Contes*, *The Adventures of Baron Münchausen*, Chateaubriand's *Atala*, Tennyson's *Idylls of the King* and, in 1866, John Milton's epic poem, *Paradise Lost*.

Doré continued to work with astonishing speed, usually drawing his designs directly onto woodblocks. Early in his career he had been upset by the low quality of engraving, and he assembled a shop of about 40 engravers— Gusmand, Pannemaker and Jonnard foremost among them—he thought competent to work on his elaborate, dramatic illustrations. Much of the credit for the success of Doré's illustrations belong to these skilled artisans. The new electrotype process made it possible for the expensive woodblocks for these works, once cut, to be duplicated indefinitely without loss of quality.

Doré's books appeared in many editions in many nations; a work such as the Doré Bible was a treasured possession of countless middle-class families. His religious and historical paintings and sculptures, to which he devoted great effort, were less successful. He died in Paris on January 23, 1883, leaving unfinished a memorial to Dumas *père* and illustrations for an edition of Shakespeare.

Paradise Lost, the major work of English poet and author John Milton (1608–1674), has been considered a masterpiece of world literature from the moment it was published in 1667. The epic story of man's fall from grace and subsequent expulsion from Eden, it is often recalled by many readers for its unparalled portrayal of Satan, a dramatic character whose high heroics intentionally wear rather poorly as the poem unfolds and the truth of his struggle against God is revealed. Following a flattering self-introduction, in which Satan portrays himself as hav-

ing suffered nobly for his cause, the nature of the beast, as it were, is steadily qualified in recollections by Satan's cohorts, through reiteration of his errors by witnesses and by the words of heavenly parties themselves. Through the revelation of his sinful path, the character of Satan is weakened. Thus the poem gradually wrests dignity away from him, devaluing his martial recollections, and awards it to humankind by virtue of Adam's humble submission to God.

Paradise Lost is also an incredibly rich poetic catalog of ancient literature and mythology. Milton masterfully weaves the multilingual poetic tradition in which he was steeped with the timeless story of the human quest for religious meaning. Epic similes abound as the blind poet describes Satan's fall and God and His Son's reaction, along with the genesis of Adam and Eve's moment of sin, as well as the consequence (tempered by the promise of redemption)—expulsion from the bower in Eden. Itself a retelling of the epic and biblical traditions, *Paradise Lost* nevertheless is a new epic, told in a new way (blank verse), clearly creating a world unlike any before or since.

The present volume includes all 50 full-page plates from Doré's original interpretation of *Paradise Lost*. The art is reproduced directly from a copy of a nineteenth-century printing of the Cassell, Petter, and Galpin edition (London and New York, n.d.) because of the superior quality of the plates. Cassell, Petter, and Galpin had already become the English publisher of a major work by Doré when in 1864 they brought out *Don Quixote*, earlier published in France by Hachette. The success of the English edition prompted the British publisher to commission the illustrations for *Paradise Lost* directly from Doré.

The original captions, consisting of brief, direct quotations from the text of the poem, also appear in this Dover edition. They relate each illustration to an incident in the epic story. Note that some captions do not quote entire lines; as this can be determined through attention to Milton's use of iambic pentameter, no ellipses mark these partial quotations—however, each caption does present a complete thought or image. At the end of each caption is the number of the book and line of the poem in which the illustrated incident occurs (in the form "I. 1–3," meaning "Book I, Lines 1 through 3"; "II. 44, 45," "Book II, Lines 44 and 45"; etc.). Subsequent to the original edition of 1667, in which the poem was presented in ten books, a second edition, restructured as twelve books, with plot summaries added to each by Milton himself, appeared in 1674, shortly before the poet's death. These summaries, transcribed from the Cassell, Petter, and Galpin edition, appear below. It is our hope that they will enhance the brief captions and provide a rich context for Doré's famous illustrations.

BOOK I

The First Book proposes, first in brief, the whole subject, man's disobedience, and the loss thereupon of Paradise, wherein he was placed; then touches the prime cause of his fall, the Serpent, or rather Satan in the Serpent; who, revolting from God, and drawing to his side many legions of angels, was, by the command of God, driven out of Heaven, with all his crew, into the great deep. Which action passed over, the Poem hastens into the midst of things, presenting Satan with his angels now falling into Hell, described here, not in the centre, for Heaven and Earth may be supposed as yet not made, certainly not yet accursed, but in a place of utter darkness, fitliest called Chaos. Here Satan, with his angels, lying on the burning lake, thunderstruck and astonished, after a certain space recovers, as from confusion, calls up to him who next in order and dignity lay by him; they confer of their miserable fall; Satan awakens all his legions, who lay till then in the same manner confounded. They rise; their numbers; array of battle; their chief leaders named, according to the idols known afterward in Canaan and the countries adjoining. To these Satan directs his speech, comforts them with hope yet of regaining Heaven, but tells them lastly of a new world, and a new kind of creature to be created, according to an ancient prophecy, or report in Heaven; for, that angels were long before this visible creation, was the opinion of many ancient fathers. To find out the truth of this prophecy, and what to determine thereon, he refers to a full council. What his associates thence attempt. Pandemonium, the palace of Satan, rises, suddenly built out of the deep: the infernal peers there sit in council.

BOOK II

The consultation begun, Satan debates whether another battle be to be hazarded for the recovery of heaven. Some advise it, others dissuade: a third proposal is preferred,

mentioned before by Satan, to search the truth of that prophecy or tradition in heaven concerning another world, and another kind of creature, equal or not much inferior to themselves, about this time to be created. Their doubt, who shall be sent on this difficult search; Satan, their chief, undertakes alone the voyage, is honoured and applauded. The council thus ended, the rest betake them several ways, and to several employments, as their inclinations lead them, to entertain the time till Satan return. He passes on his journey to hell-gates; finds them shut, and who sat there to guard them; by whom at length they are opened, and discover to him the great gulf between hell and heaven; with what difficulty he passes through, directed by Chaos, the power of that place, to the sight of this new world which he sought.

BOOK III

God, sitting on His throne, sees Satan flying towards this world, then newly created: shows him to the Son, who sat at His right hand; foretells the success of Satan in perverting mankind; clears His own justice and wisdom from all imputation, having created man free, and able enough to have withstood his tempter; yet declares His purpose of grace towards him, in regard he fell not of his own malice, as did Satan, but by him seduced. The Son of God renders praise to His Father for the manifestation of His gracious purpose towards man; but God again declares that grace cannot be extended towards man without the satisfaction of Divine justice. Man hath offended the majesty of God by aspiring to Godhead, and, therefore with all his progeny, devoted to death, must die, unless some one can be found sufficient to answer for his offence, and undergo his punishment. The Son of God freely offers himself a ransom for man: the Father accepts Him, ordains His incarnation, pronounces His exaltation above all names in heaven and earth; commands all the angels to adore Him. They obey, and by hymning to their harps in full quire, celebrate the Father and the Son. Meanwhile, Satan alights upon the bare convex of this world's outermost orb; where wandering, he first finds a place, since called the Limbo of Vanity: what persons and things fly up thither: thence comes to the gates of heaven, described ascending by stairs, and the waters above the firmament that flow about it: his passage thence to the orb of the sun; he finds there Uriel, the regent of that orb, but first changes himself into the shape of a meaner angel; and, pretending a zealous desire to behold the new creation, and man, whom God had placed there, inquires of him the place of his habitation, and is directed: alights first on Mount Niphates.

BOOK IV

Satan, now in prospect of Eden, and nigh the place where he must now attempt the bold enterprise which he undertook alone against God and man, falls into many doubts with himself, and many passions, fear, envy, and despair; but at length confirms himself in evil, journeys on to Paradise, whose outward prospect and situation is described; overleaps the bounds; sits in the shape of a cormorant on the tree of life, as the highest in the garden, to look about him. The garden described; Satan's first sight of Adam and Eve; his wonder at their excellent form and happy state, but with resolution to work their fall; overhears their discourse, thence gathers that the tree of knowledge was forbidden them to eat of, under penalty of death; and thereon intends to found his temptation, by seducing them to transgress; then leaves them awhile to know farther of their state by some other means. Meanwhile, Uriel, descending on a sunbeam, warns Gabriel, who had in charge the gate of Paradise, that some evil spirit had escaped the deep, and passed at noon by his sphere, in the shape of a good angel, down to Paradise, discovered after by his furious gestures in the mount. Gabriel promises to find him ere morning. Night coming on, Adam and Eve discourse of going to their rest: their bower described; their evening worship. Gabriel, drawing forth his bands of night-watch to walk the rounds of Paradise, appoints two strong angels to Adam's bower, lest the evil spirit should be there doing some harm to Adam or Eve sleeping; there they find him at the ear of Eve, tempting her in a dream, and bring him, though unwilling, to Gabriel; by whom questioned, he scornfully answers; prepares resistance; but, hindered by a sign from heaven, flies out of Paradise.

BOOK V

Morning approached, Eve relates to Adam her troublesome dream; he likes it not, yet comforts her; they come forth to their day-labours; their morning hymn at the door of their bower. God, to render man inexcusable, sends Raphael to admonish him of his obedience, of his free estate, of his enemy near at hand, who he is, and why his enemy, and whatever else may avail Adam to know. Raphael comes down to Paradise; his appearance described; his coming discerned by Adam afar off, sitting at the door of his bower; he goes out to meet him, brings him to his lodge, entertains him with the choicest fruits of Paradise, got together by Eve; their discourse at table; Raphael performs his message, minds Adam of his state and of his enemy; relates, at Adam's request, who that enemy is, and how he came to be so, beginning from the

first revolt in heaven, and the occasion thereof; how he drew his legions after him to the parts of the north, and there incited them to rebel with him, persuading all but only Abdiel, a seraph, who in argument dissuades and opposes him, then forsakes him.

BOOK VI

Raphael continues to relate how Michael and Gabriel were sent forth to battle against Satan and his angels. The first fight described: Satan and his powers retire under night: he calls a council; invents devilish engines, which, in the second day's fight, put Michael and his angels to some disorder; but they at length pulling up mountains, overwhelm both the force and machines of Satan: yet the tumult not so ending, God, on the third day, sends Messiah his Son, for whom he had reserved the glory of that victory; He, in the power of his Father, coming to the place, and causing all his legions to stand still on either side, with his chariot and thunder driving into the midst of his enemies, pursues them, unable to resist, towards the wall of heaven; which opening, they leap down with horror and confusion into the place of punishment prepared for them in the deep: Messiah returns with triumph to his Father.

BOOK VII

Raphael, at the request of Adam, relates how and wherefore this world was first created; that God, after the expelling of Satan and his angels out of heaven, declared His pleasure to create another world, and other creatures to dwell therein; sends His Son with glory, and attendance of angels, to perform the work of creation in six days: the angels celebrate with hymns the performance thereof, and His re-ascension into Heaven.

BOOK VIII

Adam inquires concerning celestial motions; is doubtfully answered, and exhorted to search rather things more worthy of knowledge; Adam assents; and, still desirous to detain Raphael, relates to him what he remembered since his own creation; his placing in Paradise; his talk with God concerning solitude and fit society; his first meeting and nuptials with Eve; his discourse with the angel thereupon, who, after admonitions repeated, departs.

BOOK IX

Satan, having compassed the earth, with meditated guile returns, as a mist, by night, into Paradise; enters into the serpent sleeping. Adam and Eve in the morning go forth to their labours, which Eve proposes to divide in several places, each labouring apart; Adam consents not, alleging the danger lest that enemy of whom they were forewarned, should attempt her, found alone: Eve, loth to be thought not circumspect or firm enough, urges her going apart, the rather desirous to make trial of her strength; Adam at last yields; the serpent finds her alone: his subtle approach, first gazing, then speaking; with much flattery extolling Eve above all other creatures. Eve, wondering to hear the serpent speak, asks how he attained to human speech, and such understanding, not till now; the serpent answers that, by tasting of a certain tree in the garden, he attained both to speech and reason, till then void of both. Eve requires him to bring her to that tree, and finds it to be the tree of knowledge, forbidden: the serpent, now grown bolder, with many wiles and arguments induces her at length to eat; she, pleased with the taste, deliberates awhile whether to impart thereof to Adam or not; at last brings him of the fruit: relates what persuaded her to eat thereof. Adam, at first amazed, but perceiving her lost, resolves, through vehemence of love, to perish with her; and, extenuating the trespass, eats also of the fruit: the effects thereof in them both; they seek to cover their nakedness; then fall to variance and accusation of one another.

BOOK X

Man's transgression known, the guardian angels forsake Paradise, and return up to heaven to approve their vigilance, and are approved; God declaring that the entrance of Satan could not be by them prevented. He sends His Son to judge the transgressors; who descends, and gives sentence accordingly; then, in pity, clothes them both, and re-ascends. Sin and Death, sitting till then at the gates of hell, by wondrous sympathy feeling the success of Satan in this new world, and the sin by man there committed, resolve to sit no longer confined in hell, but to follow Satan, their sire, up to the place of man. To make the way easier from hell to this world to and fro, they pave a broad highway or bridge over Chaos, according to the track that Satan first made; then, preparing for earth, they meet him, proud of his success, returning to hell; their mutual gratulation. Satan arrives at Pandemonium; in full assembly relates, with boasting, his success against man; instead of applause is entertained with a general hiss by all his audience, transformed, with himself also, suddenly into serpents, according to his doom given in Paradise; then, deluded with a show of the forbidden tree springing up

before them, they, greedily reaching to take of the fruit, chew dust and bitter ashes. The proceedings of Sin and Death; God foretells the final victory of His Son over them, and the renewing of all things; but, for the present, commands His angels to make several alterations in the heavens and elements. Adam, more and more perceiving his fallen condition, heavily bewails, rejects the condolement of Eve; she persists, and at length appeases him: then, to evade the curse likely to fall on their offspring, proposes to Adam violent ways, which he approves not; but, conceiving better hope, puts her in mind of the late promise made them, that her seed should be revenged on the serpent; and exhorts her, with him, to seek peace of the offended Deity, by repentance and supplication.

BOOK XI

The Son of God presents to His Father the prayers of our first parents now repenting, and intercedes for them: God accepts them, but declares that they must no longer abide in Paradise; sends Michael with a band of cherubim to dispossess them; but first to reveal to Adam future things: Michael's coming down. Adam shows to Eve certain ominous signs: he discerns Michael's approach; goes out to meet him: the angel denounces their departure. Eve's lamentation. Adam pleads, but submits: the angel leads him up to a high hill; sets before him in vision that shall happen till the flood.

BOOK XII

The Angel Michael continues, from the flood, to relate what shall succeed; then, in the mention of Abraham, comes by degrees to explain who that seed of the woman shall be which was promised Adam and Eve in the fall: His incarnation, death, resurrection, and ascension; the state of the Church till His second coming. Adam, greatly satisfied and re-comforted by these relations and promises, descends the hill with Michael; wakens Eve, who all this while had slept, but with gentle dreams composed to quietness of mind and submission. Michael, in either hand leads them out of Paradise, the fiery sword waving behind them, and the cherubim taking their stations to guard the place.

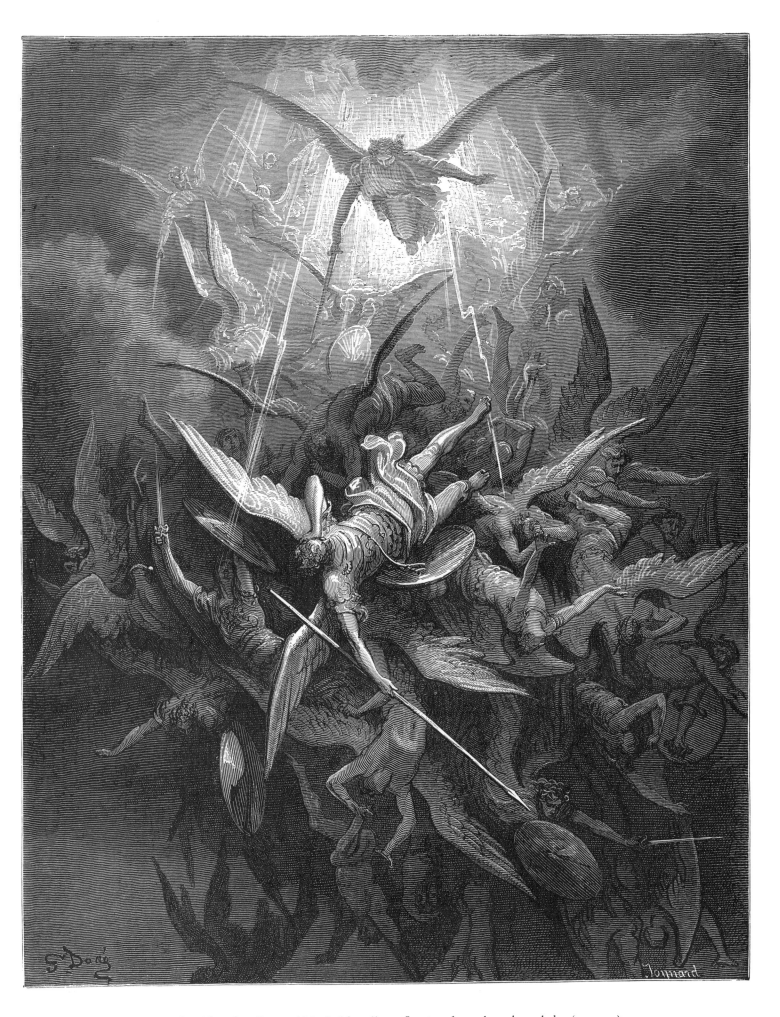

Him the Almighty Power / Hurled headlong flaming from the ethereal sky (I. 44, 45).

I

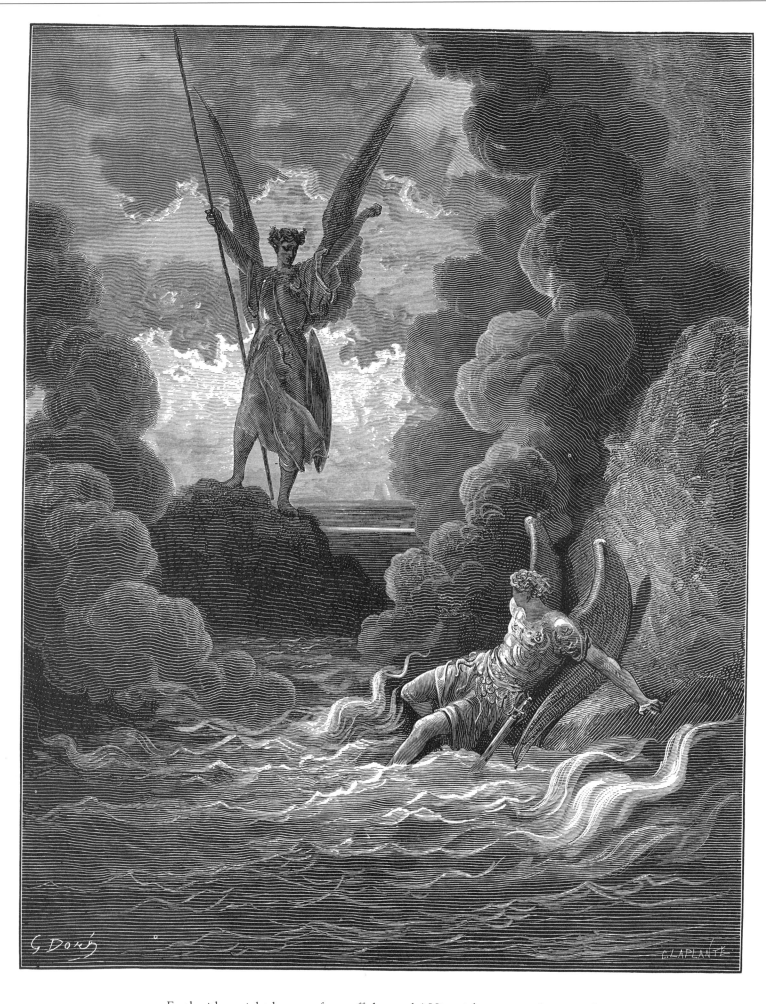

Forthwith upright he rears from off the pool / His mighty stature (I. 221, 222).

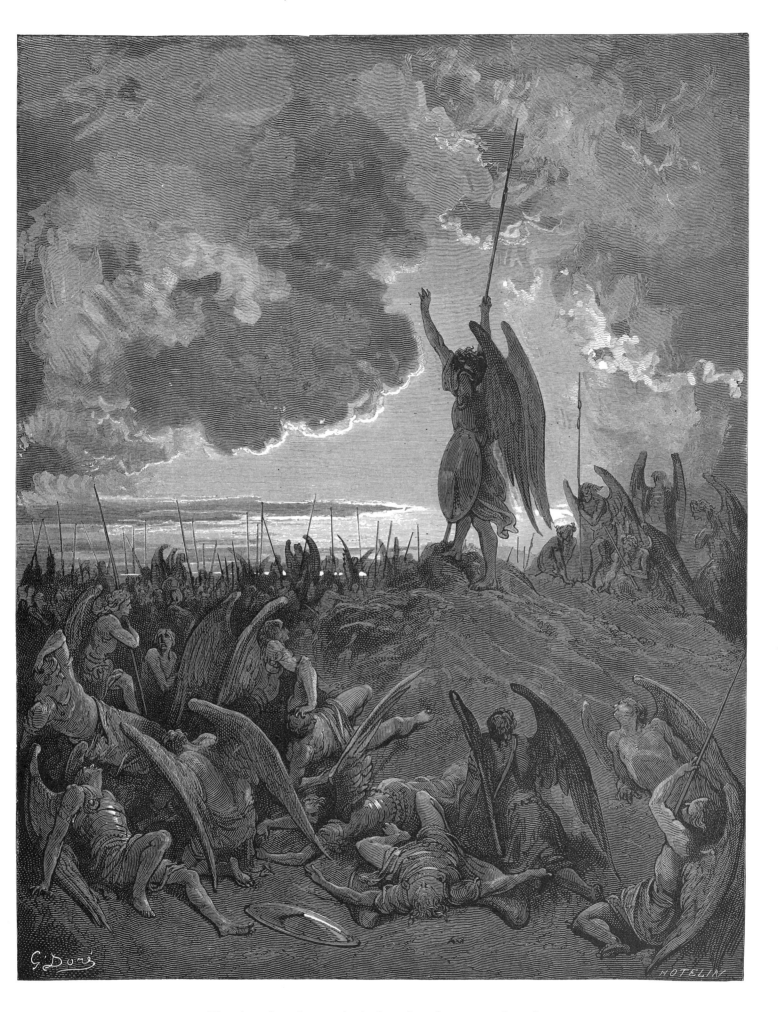

They heard, and were abashed, and up they sprung (I. 331).

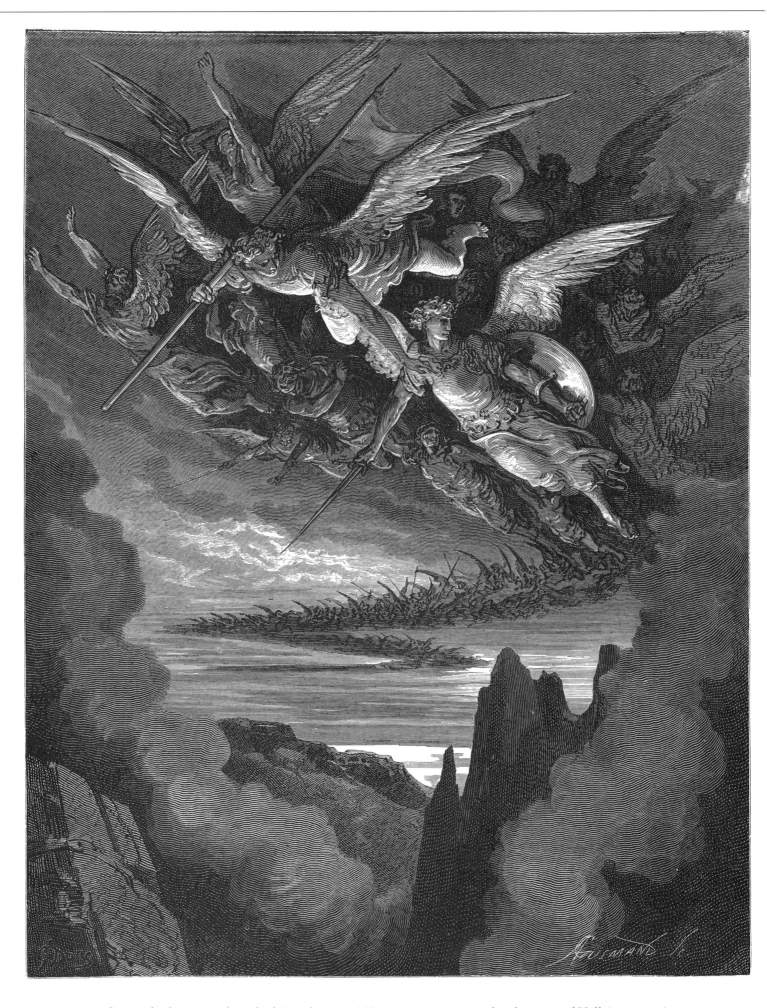

So numberless were those bad Angels seen, / Hovering on wing, under the cope of Hell (I. 344, 345).

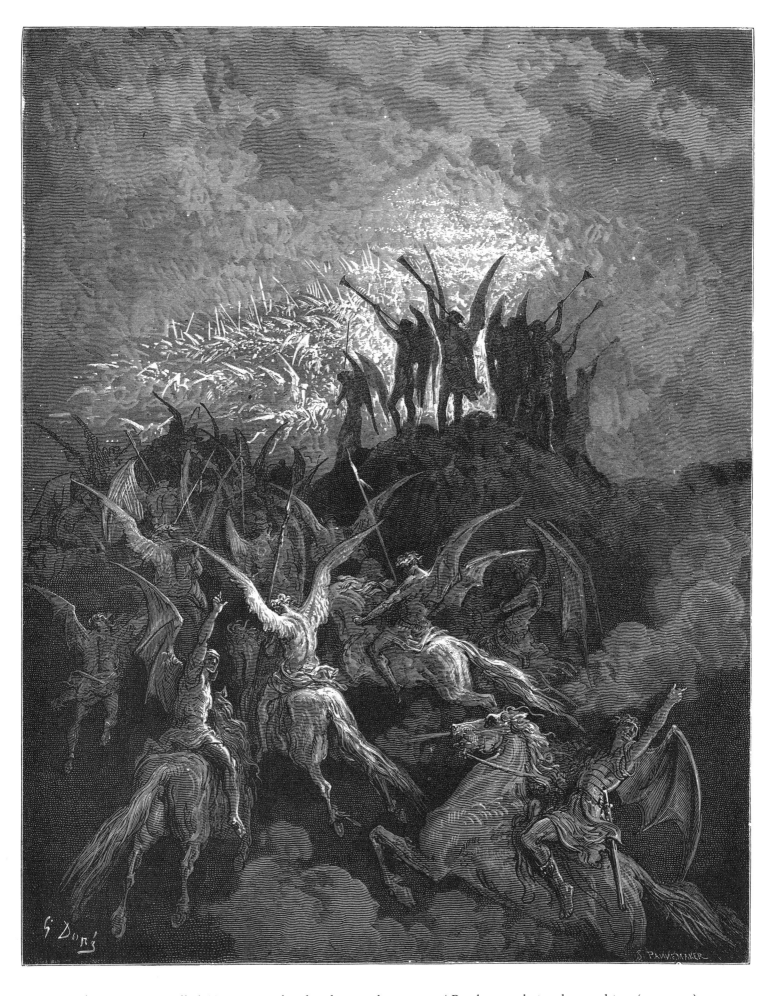

Their summons called / From every band and squared regiment, / By place or choice the worthiest (I. 757–759).

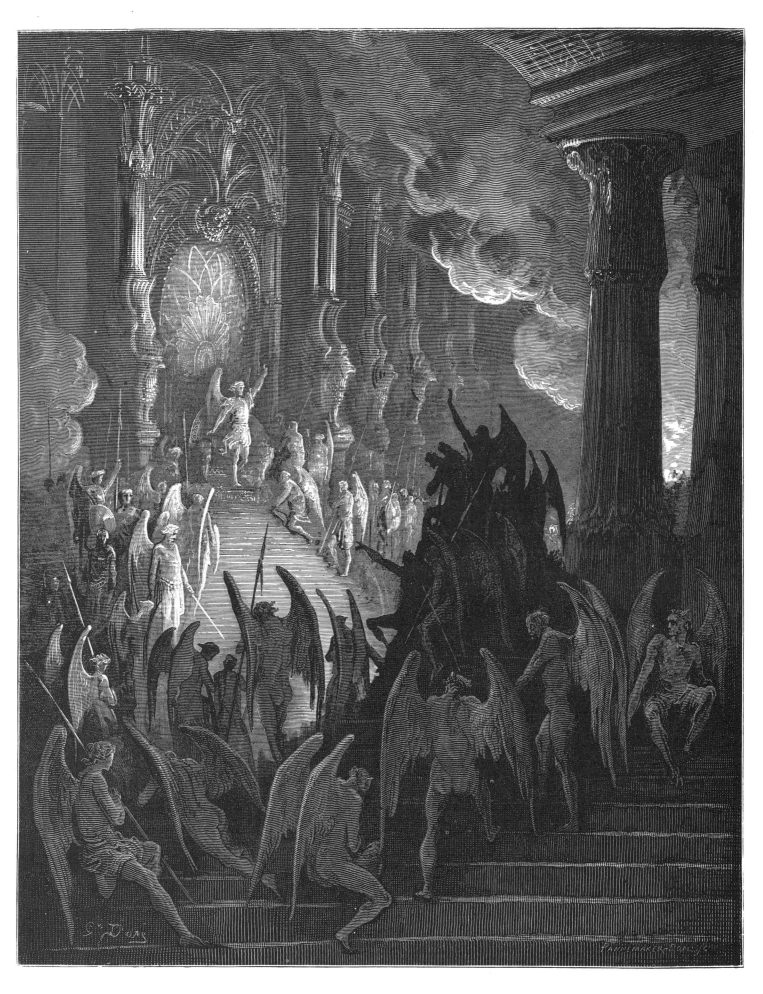

High on a throne of a royal state, which far / Outshone the wealth of Ormus and of Ind (II. 1, 2).

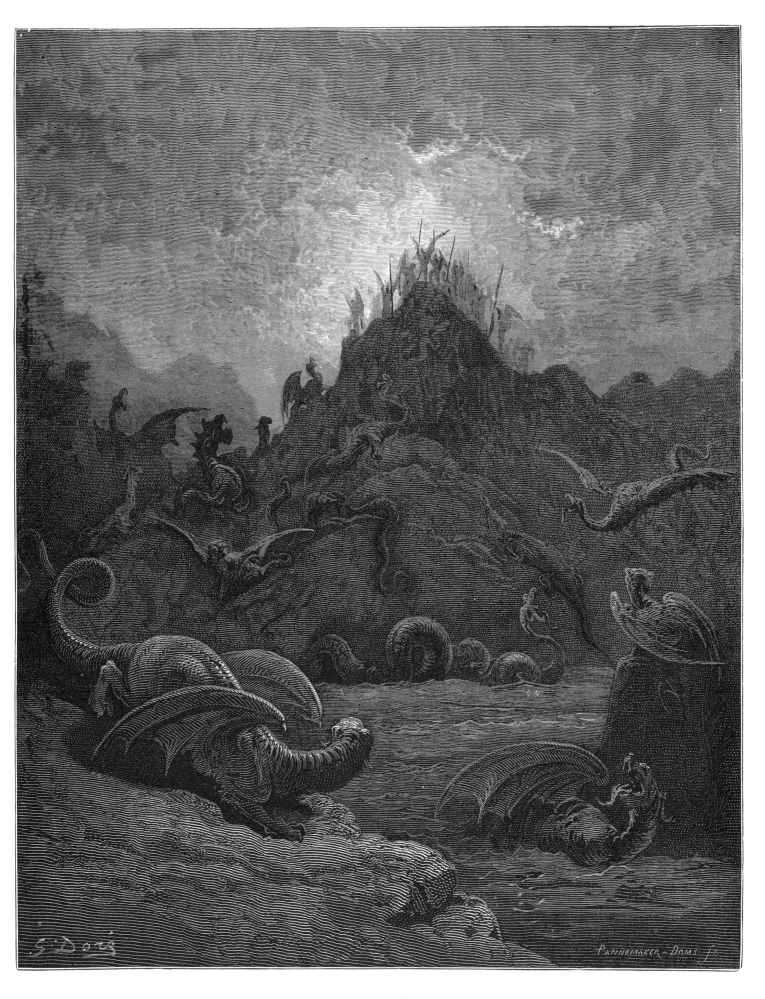

Gorgons, and Hydras, and Chimeras dire (II. 628).

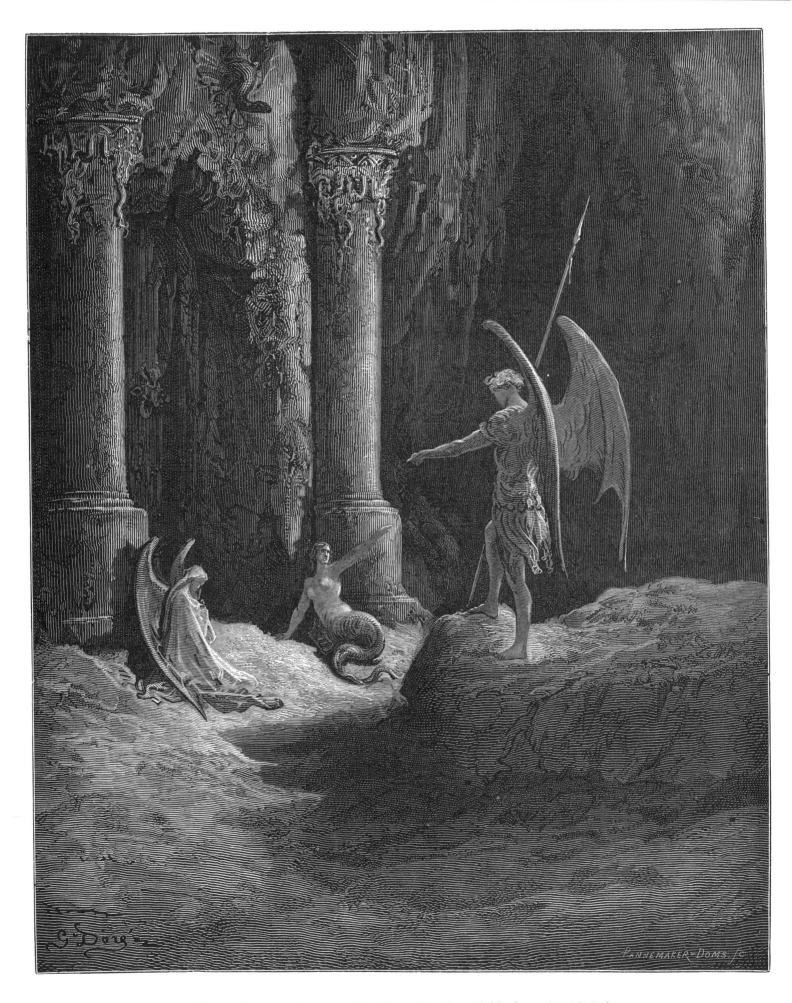

Before the gates there sat / On either side a formidable shape (II. 648, 649).

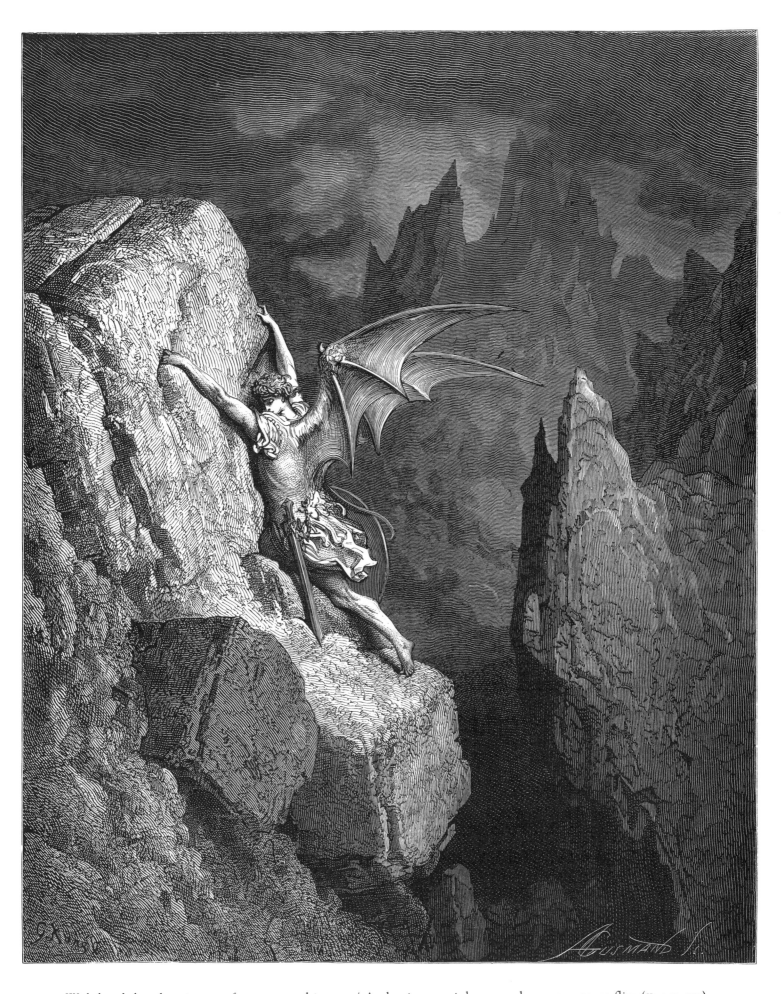

With head, hands, wings, or feet, pursues his way, / And swims, or sinks, or wades, or creeps, or flies (II. 949, 950).

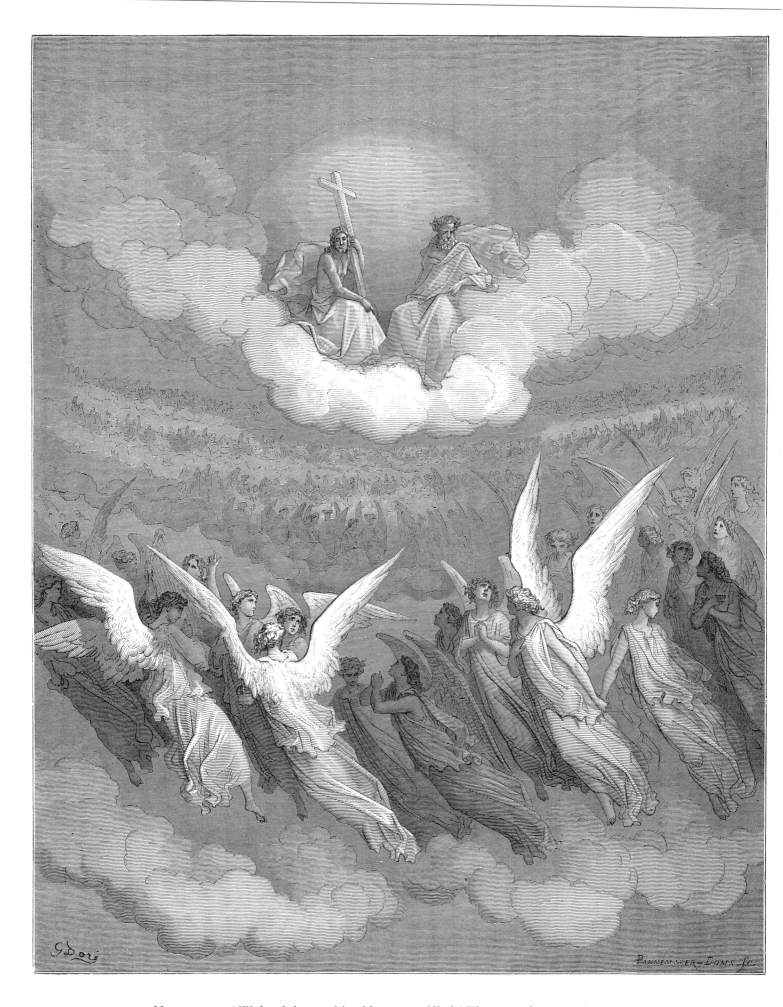

Heaven rung / With jubilee, and loud hosannas filled / The eternal regions (III. 347–349).

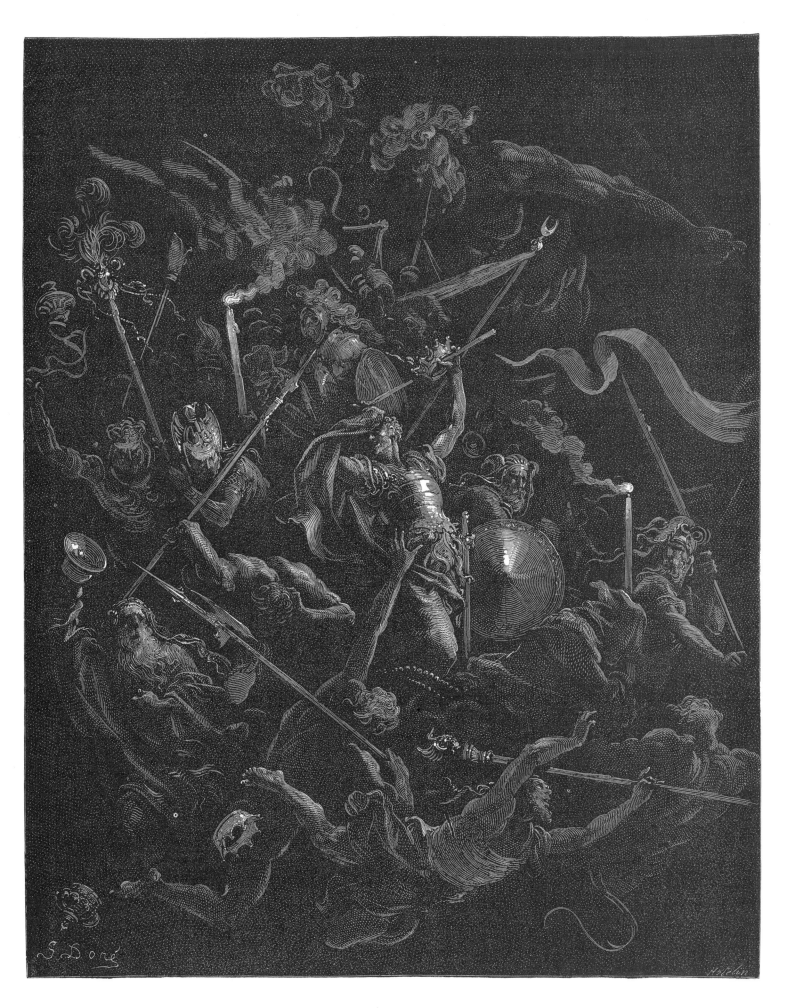

And many more too long, / Embryos, and idiots, eremites, and friars (III. 473, 474).

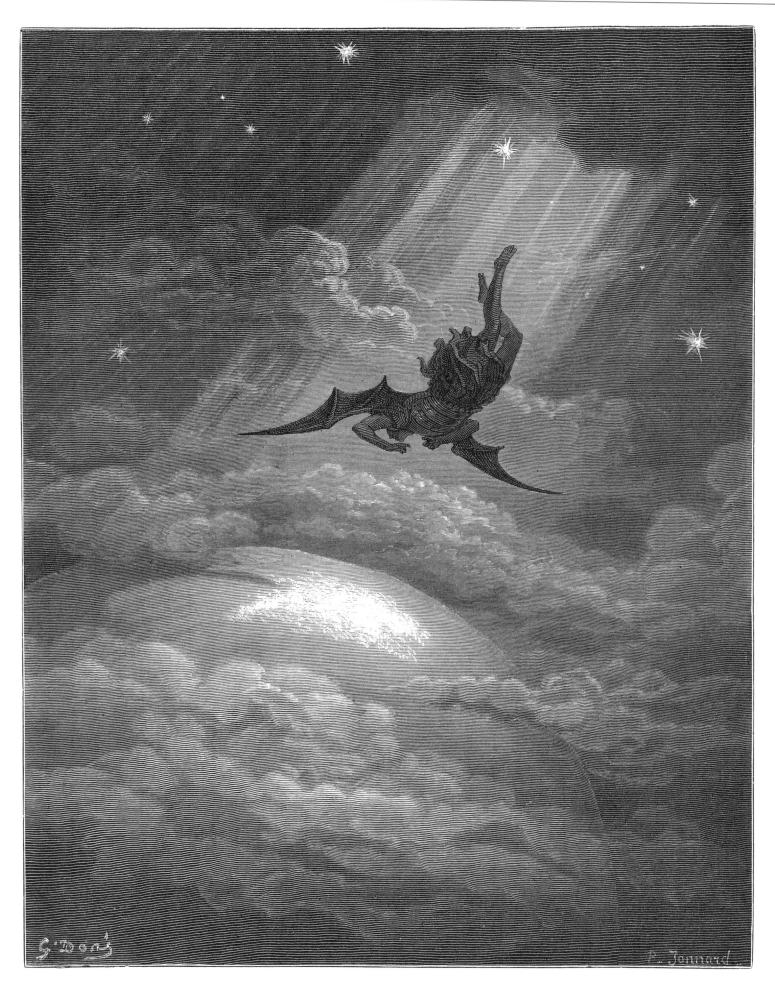

Towards the coast of Earth beneath, / Down from the ecliptic, sped with hoped success, / Throws his steep flight
in many an aëry wheel (III. 739–741).

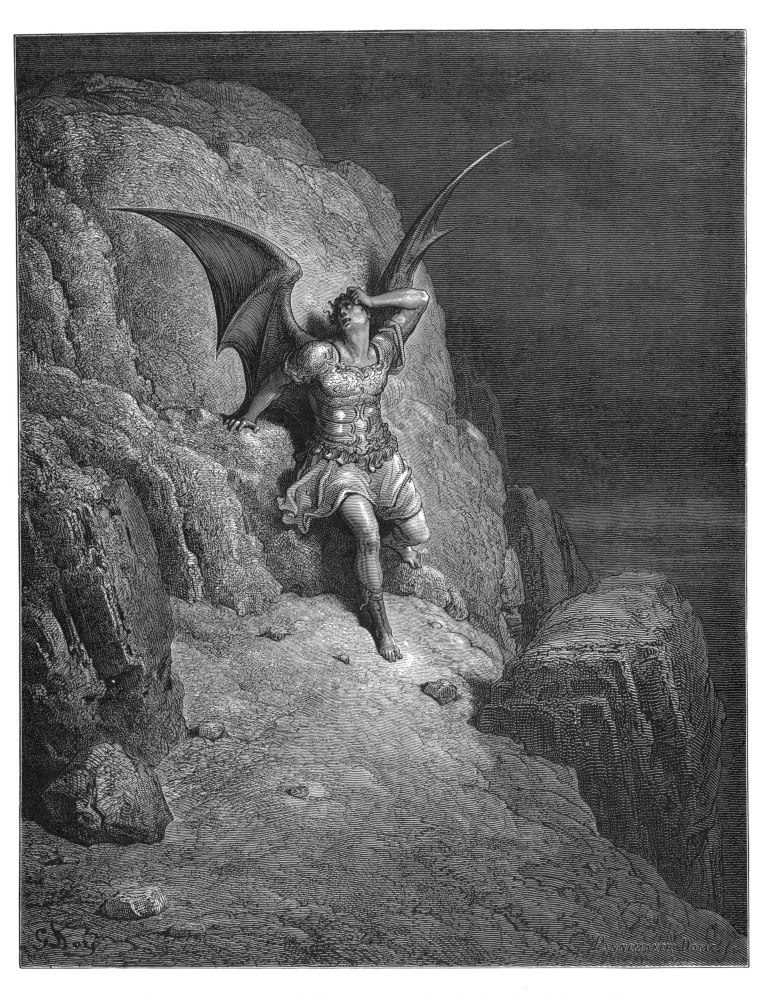

Me miserable! which way shall I fly / Infinite wrath, and infinite despair? (IV. 73, 74).

13

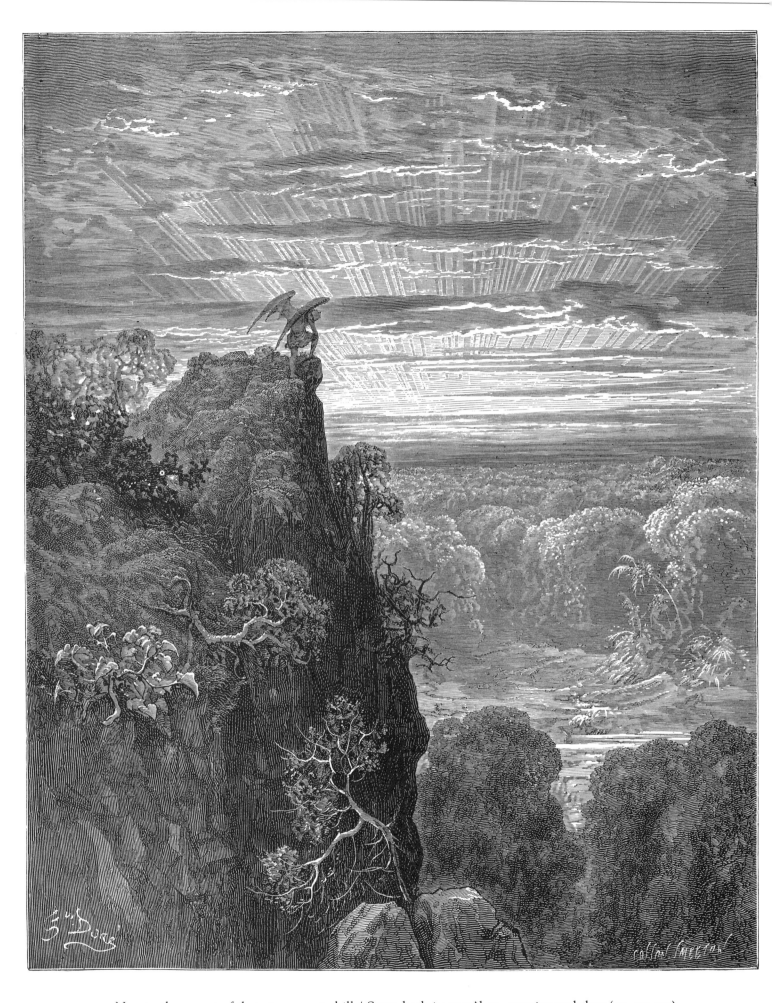

Now to the ascent of that steep savage hill / Satan hath journey'd on, pensive and slow (IV. 172, 173).

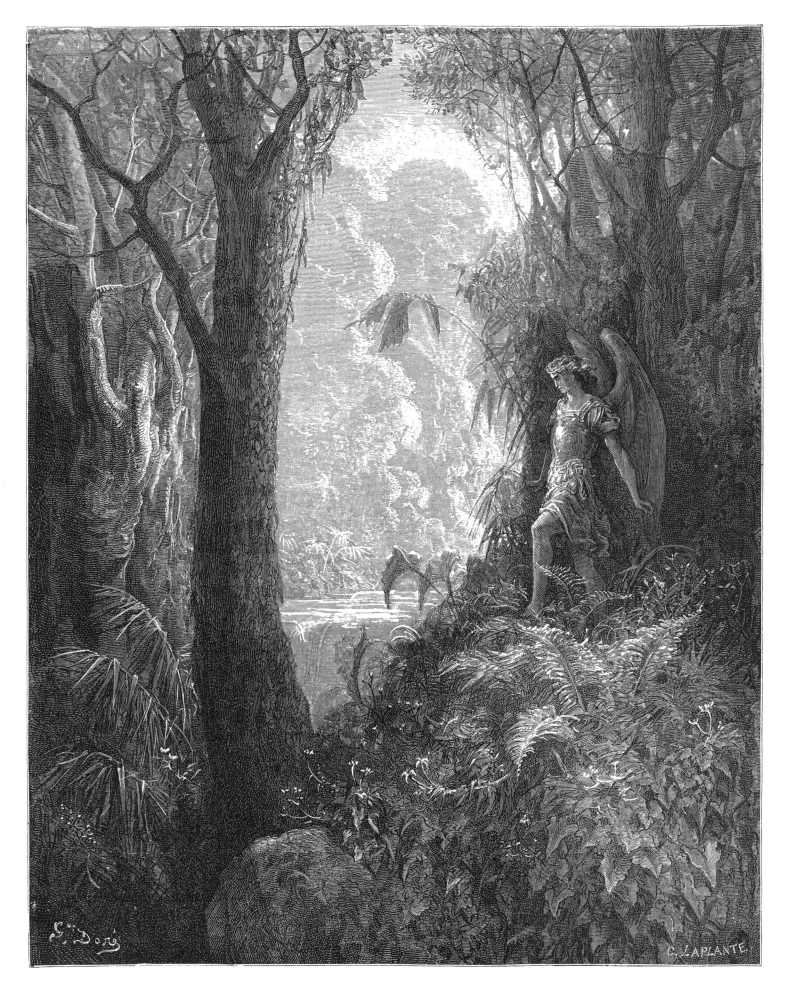

A happy rural seat of various view (IV. 247).

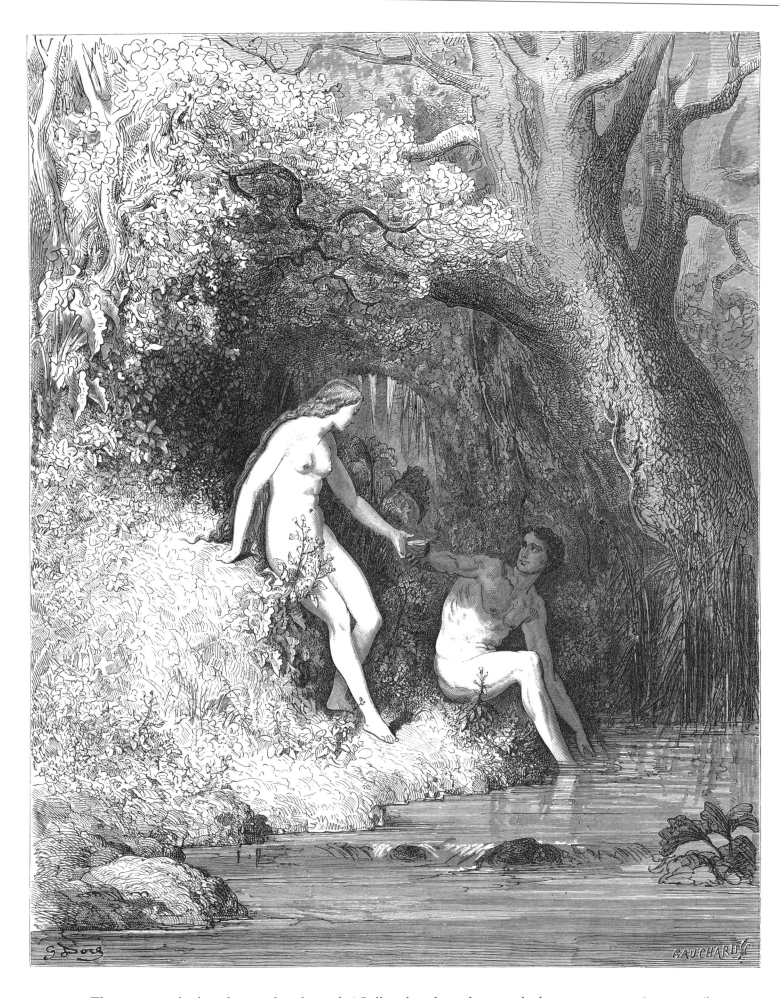

The savoury pulp they chew, and in the rind, / Still as they thirsted, scoop the brimming stream (IV. 335, 336).

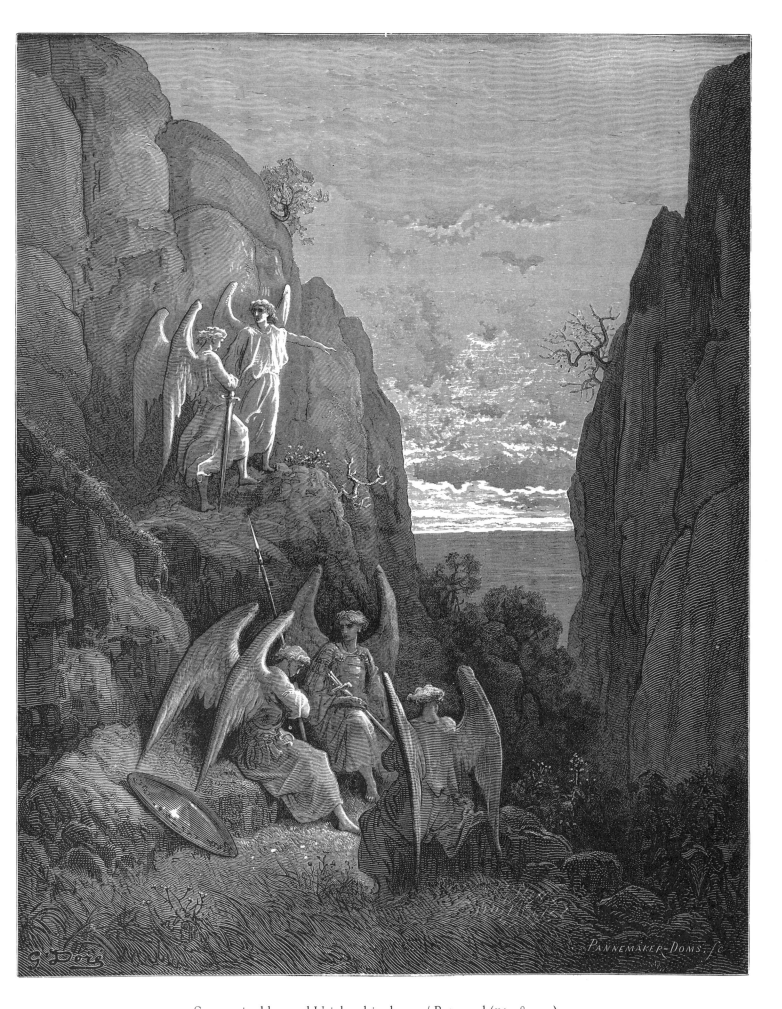

So promised he; and Uriel to his charge / Returned (IV. 589, 590).

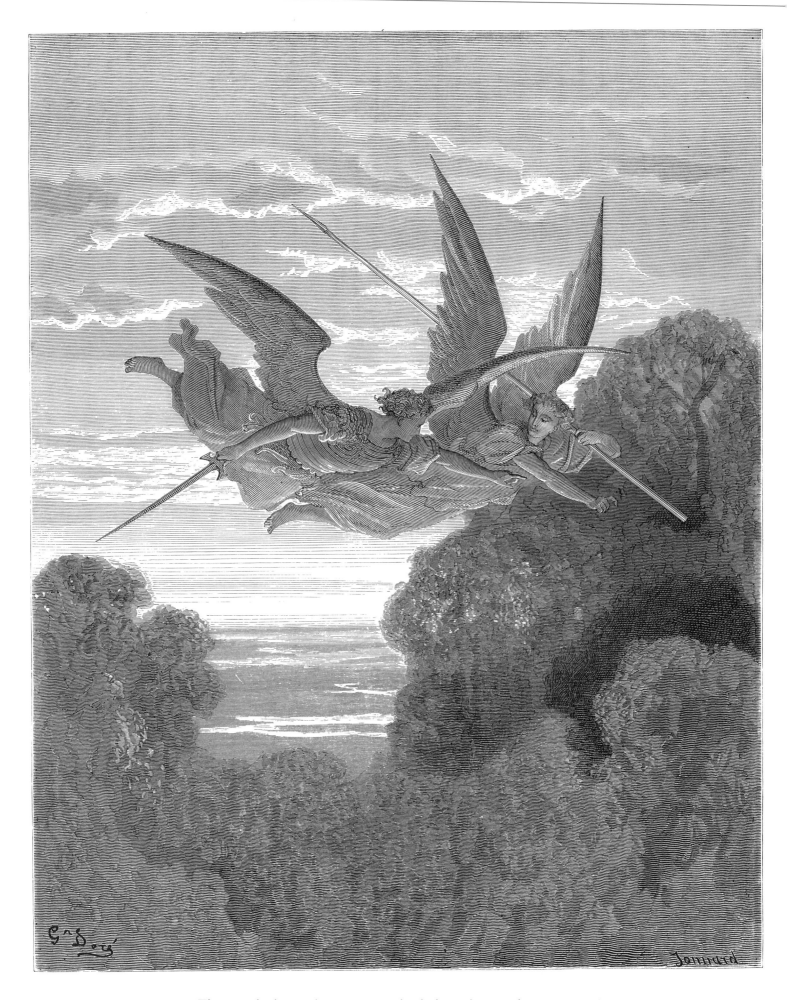

These to the bower direct / In search of whom they sought (IV. 798, 799).

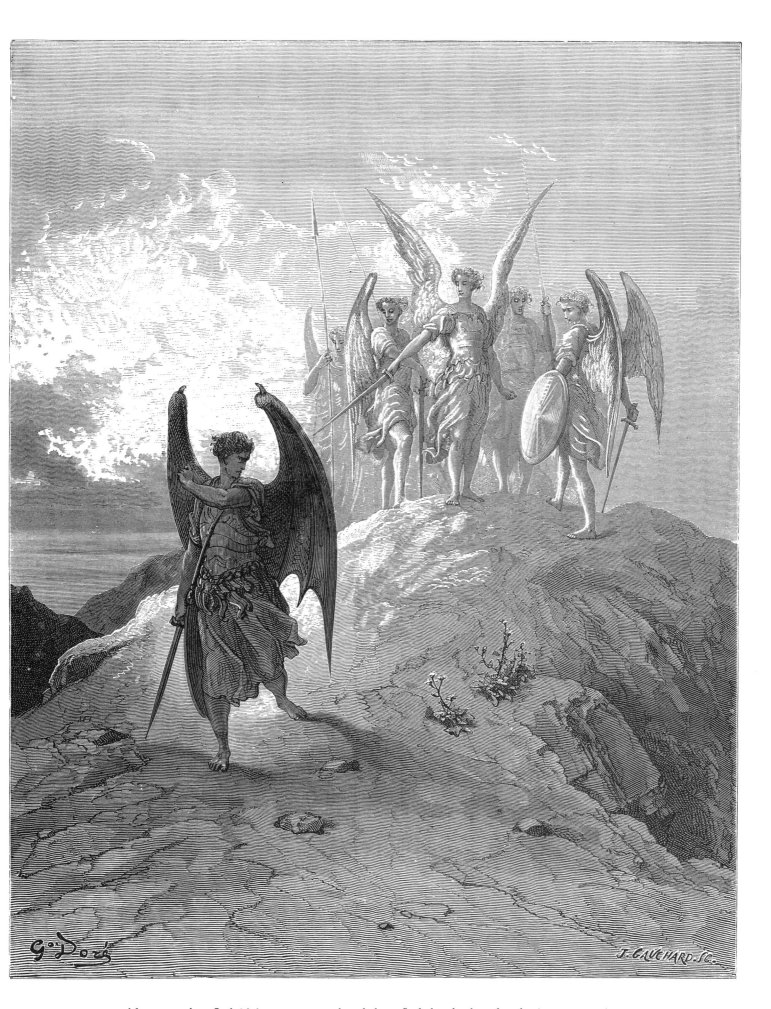

Nor more; but fled / Murmuring, and with him fled the shades of night (IV. 1014, 1015).

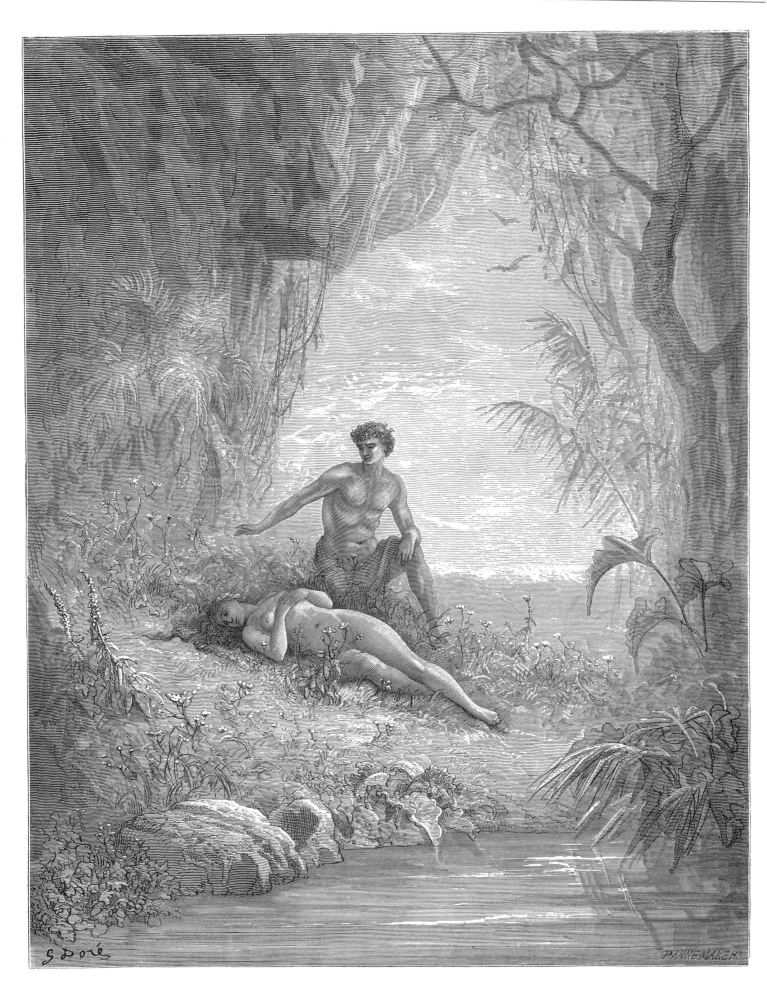

Leaning, half raised, with looks of cordial love, / Hung over her enamoured (V. 12, 13).

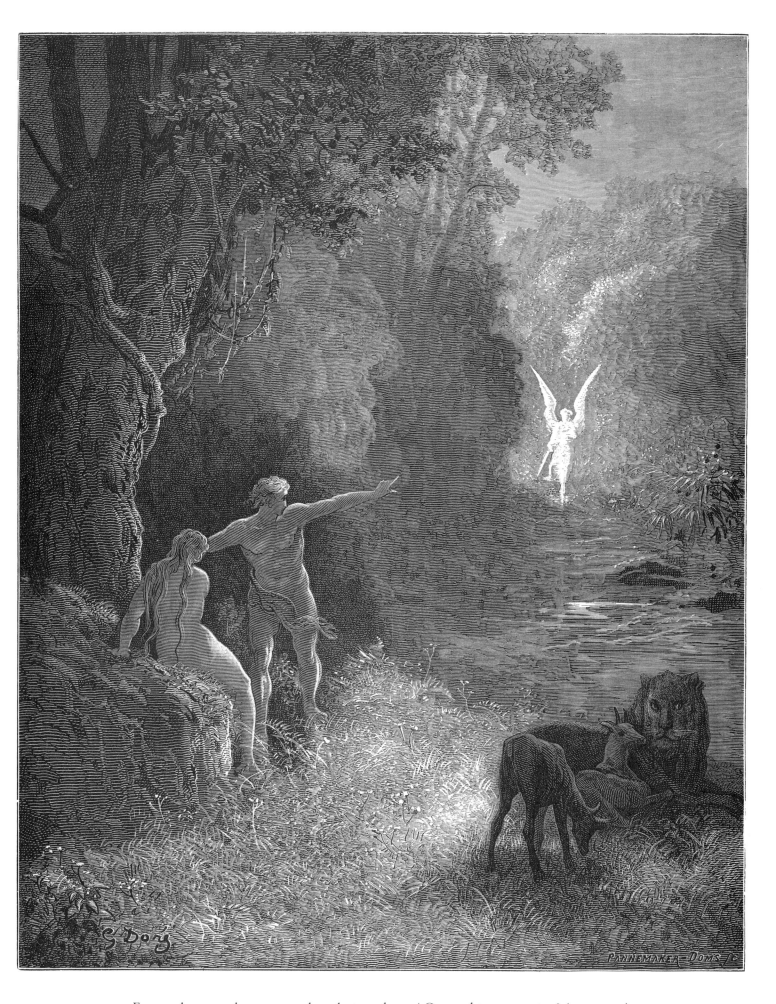

Eastward among those trees, what glorious shape / Comes this way moving? (V. 309, 310).

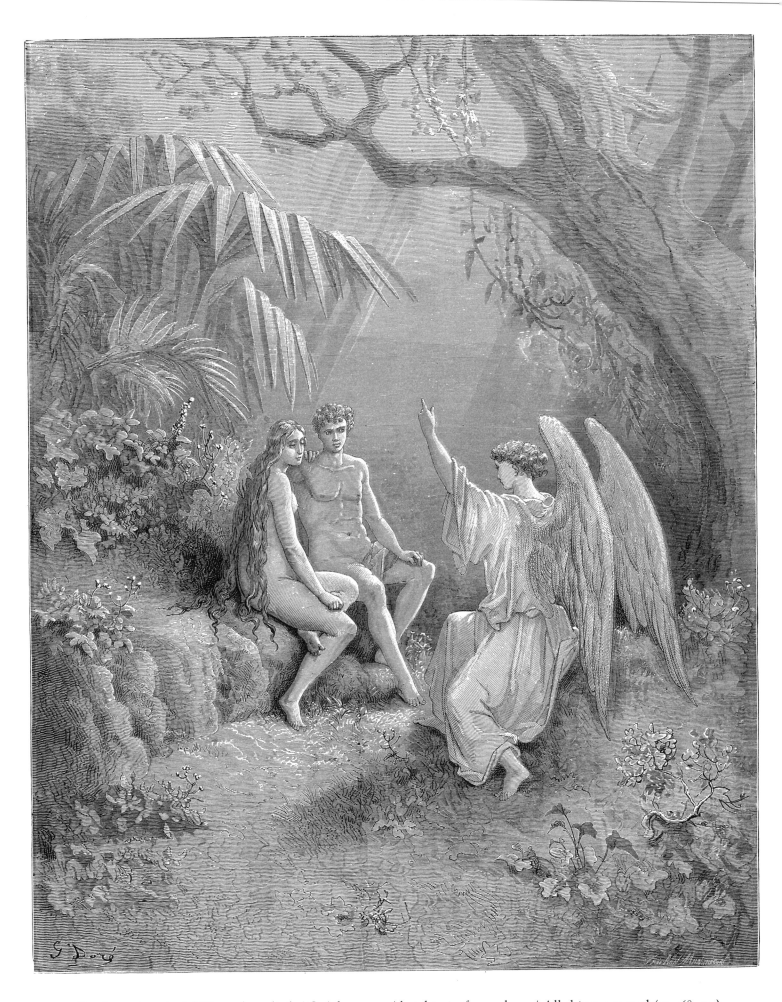

To whom the wingèd Hierarch replied: / O Adam, one Almighty is, from whom / All things proceed (V. 468–470).

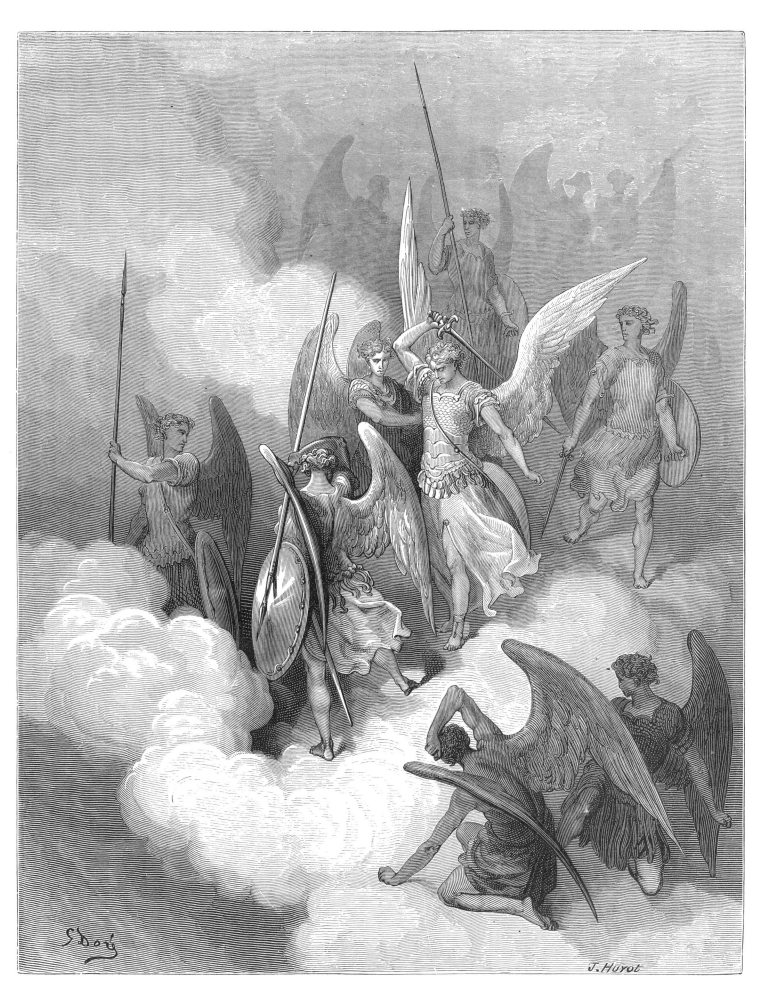

This greeting on thy impious crest receive (VI. 188).

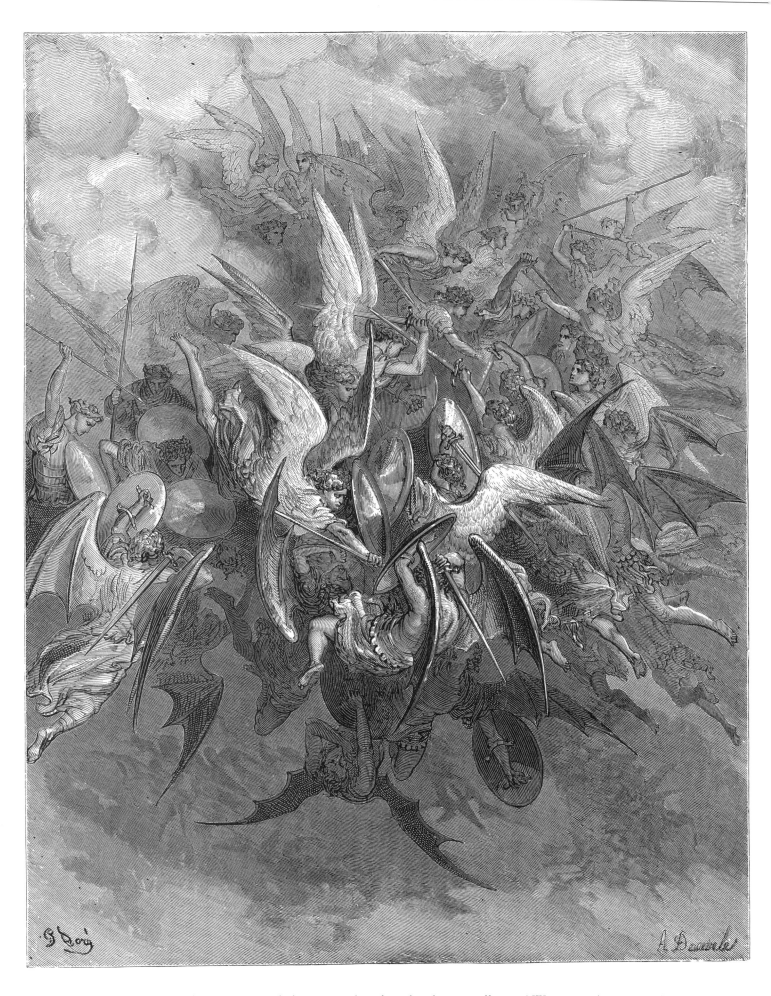

Now storming fury rose, / And clamour, such as heard in heaven till now / Was never (VI. 207–209).

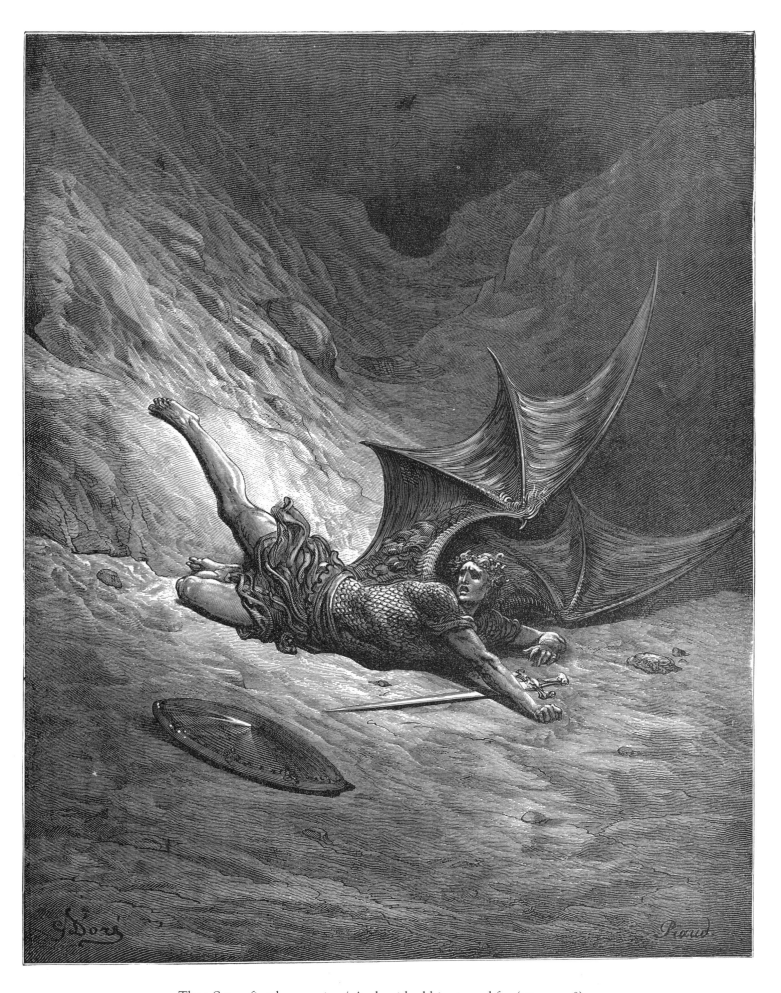

Then Satan first knew pain, / And writhed him to and fro (VI. 327, 328).

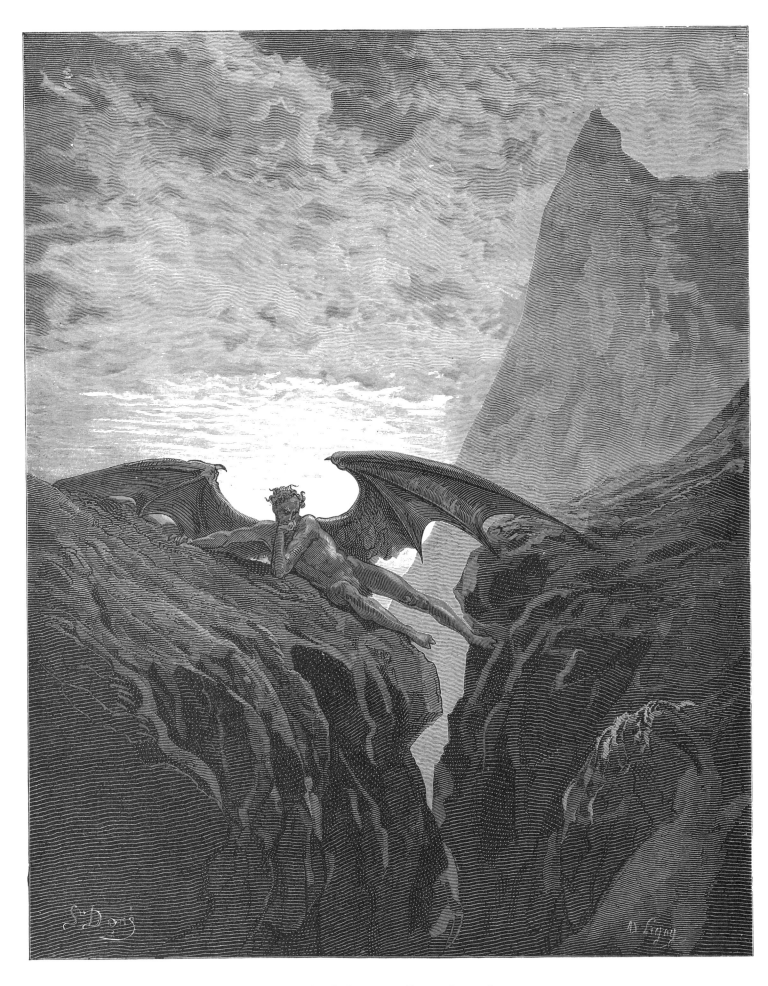

Now Night her course began (VI. 406).

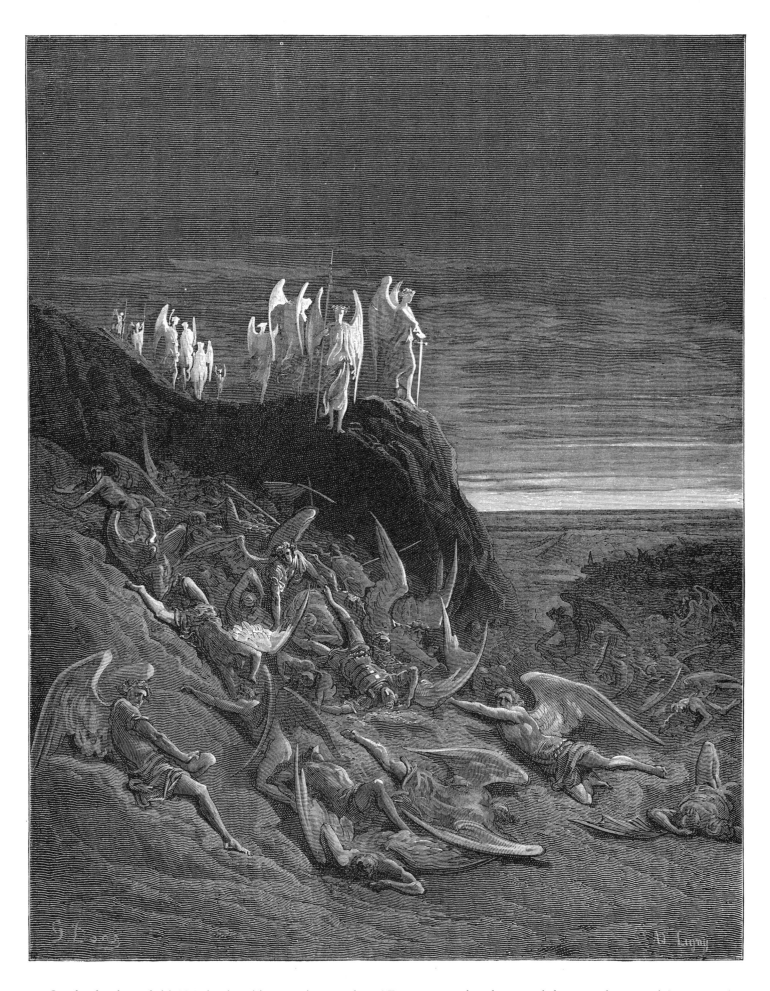

On the foughten field / Michaël and his angels, prevalent / Encamping, placed in guard their watches round (VI. 410–412).

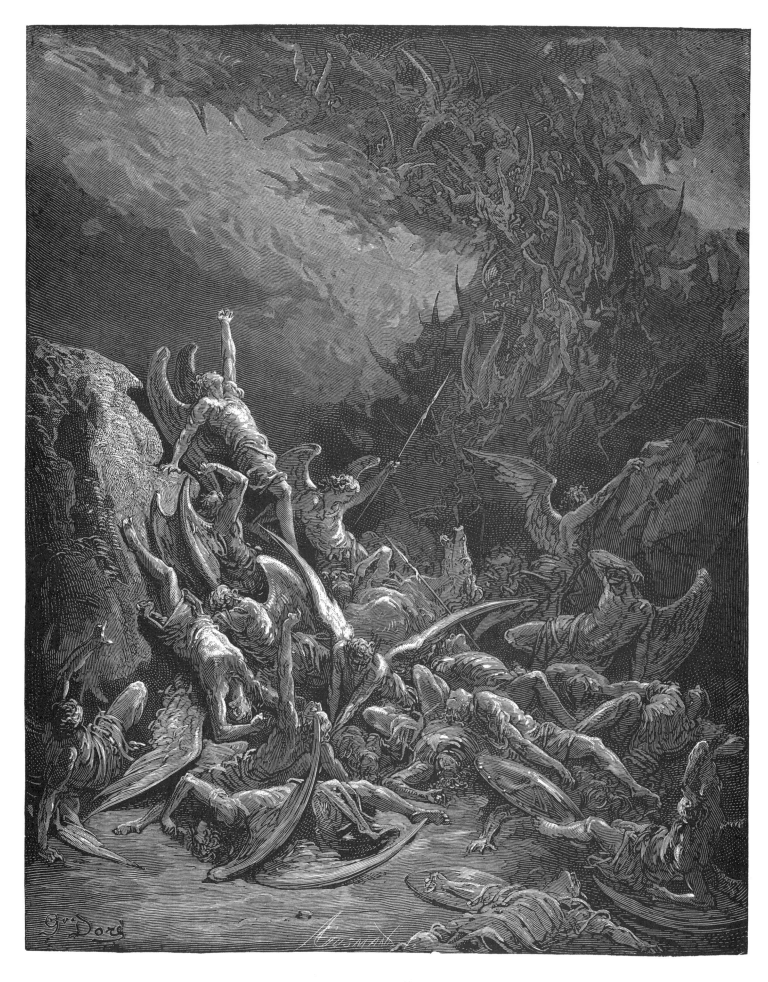

Nine days they fell (VI. 871).

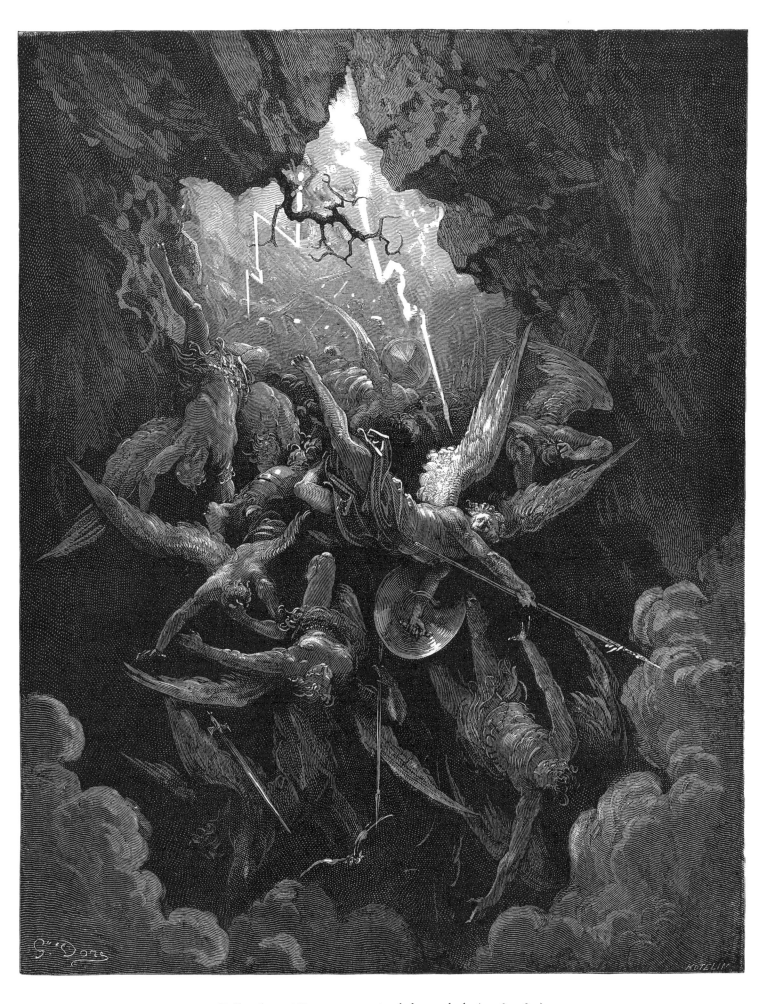

Hell at last, / Yawning, received them whole (VI. 874, 875).

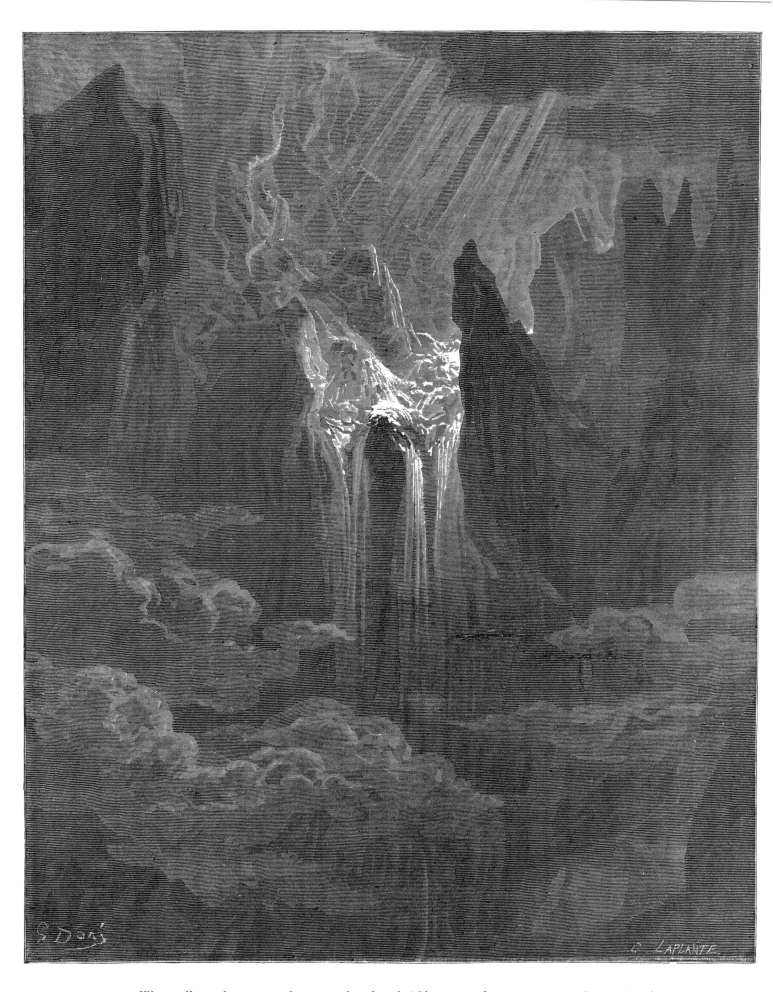

Wave rolling after wave, where way they found; / If steep, with torrent rapture (VII. 298, 299).

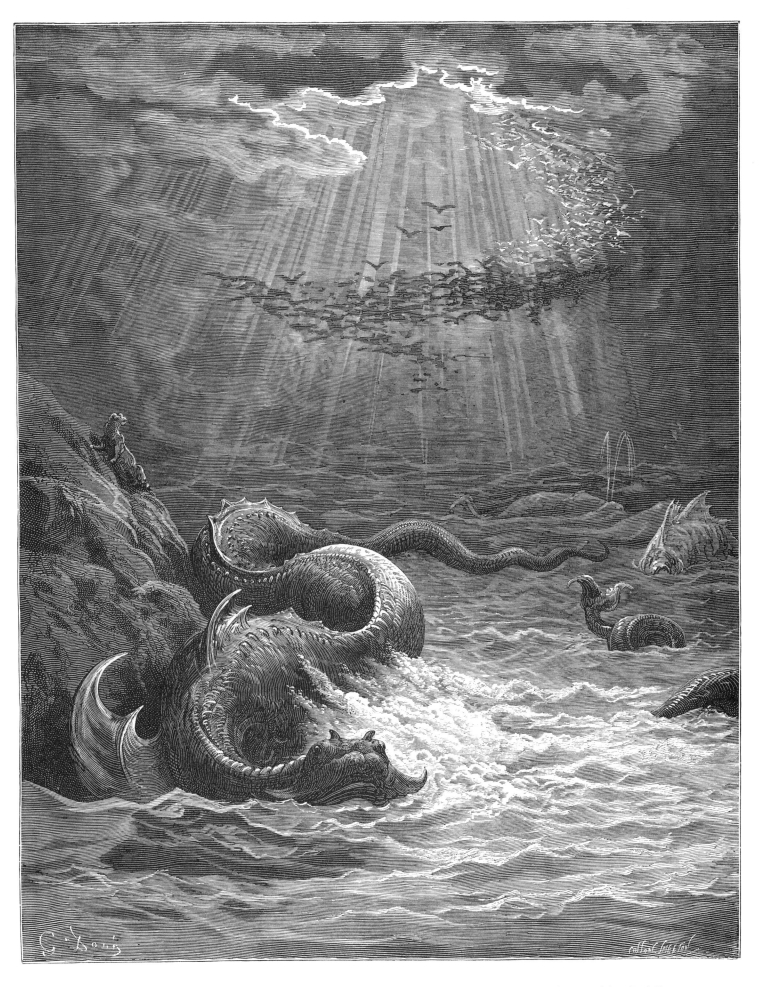

And God said: Let the waters generate / Reptile with spawn abundant, living soul; / And let fowl fly above the earth (VII. 387–389).

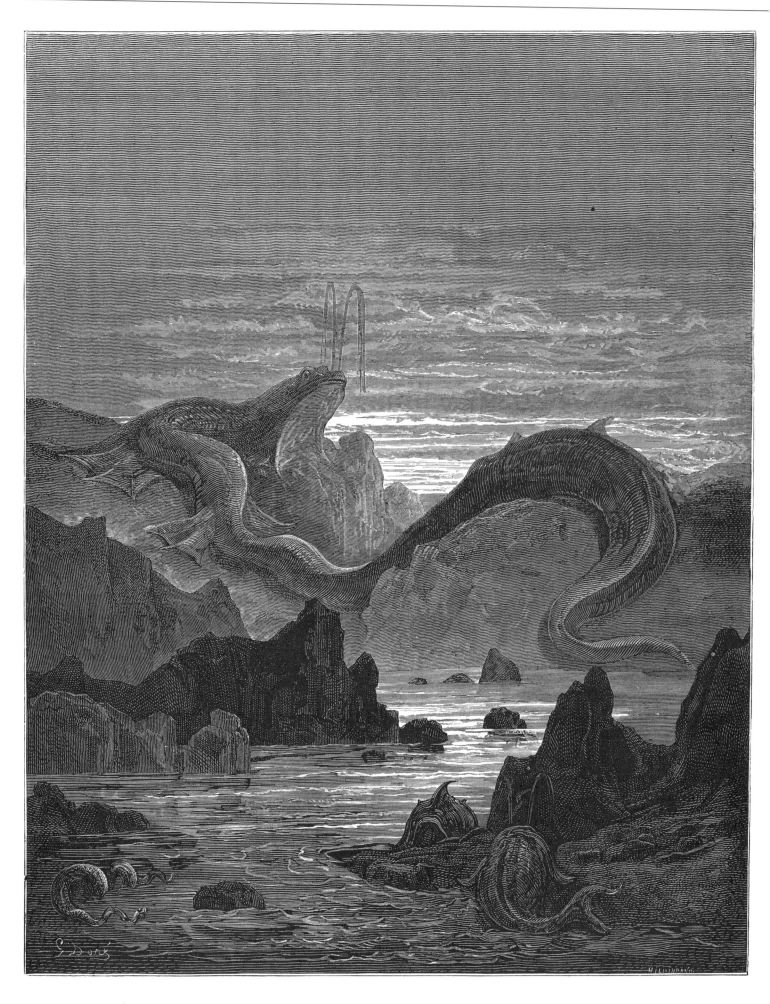

And seems a moving land; and at his gills / Draws in, and at his trunk spouts out, a sea (VII. 415, 416).

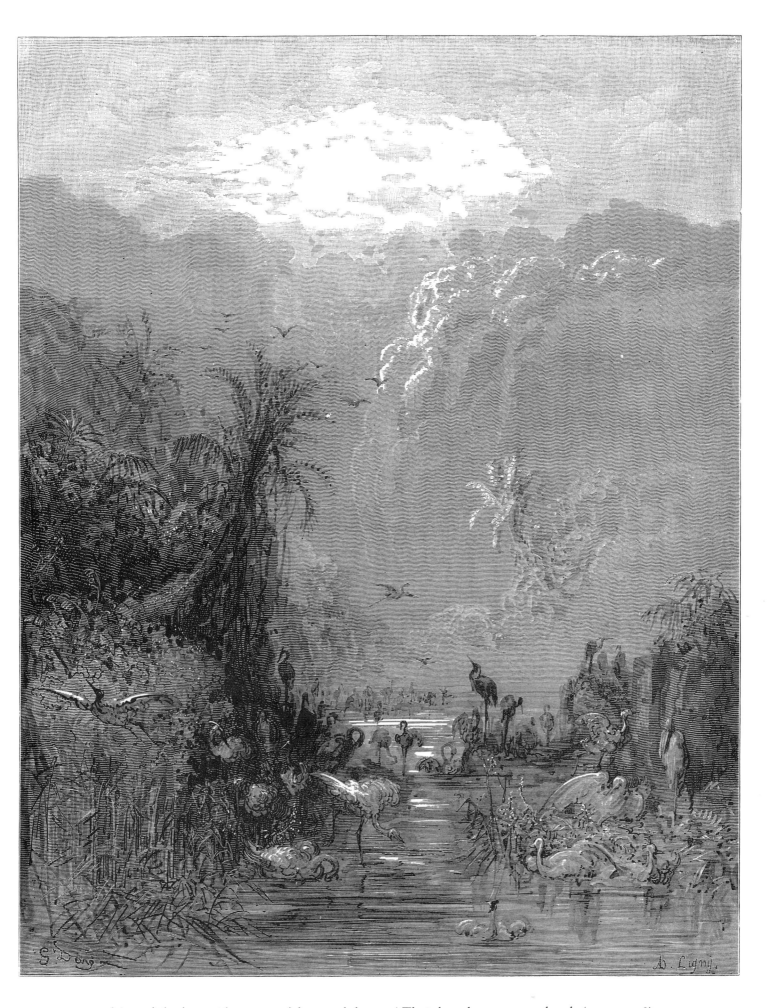

Meanwhile the tepid caves, and fens, and shores, / Their brood as numerous hatch (VII. 417, 418).

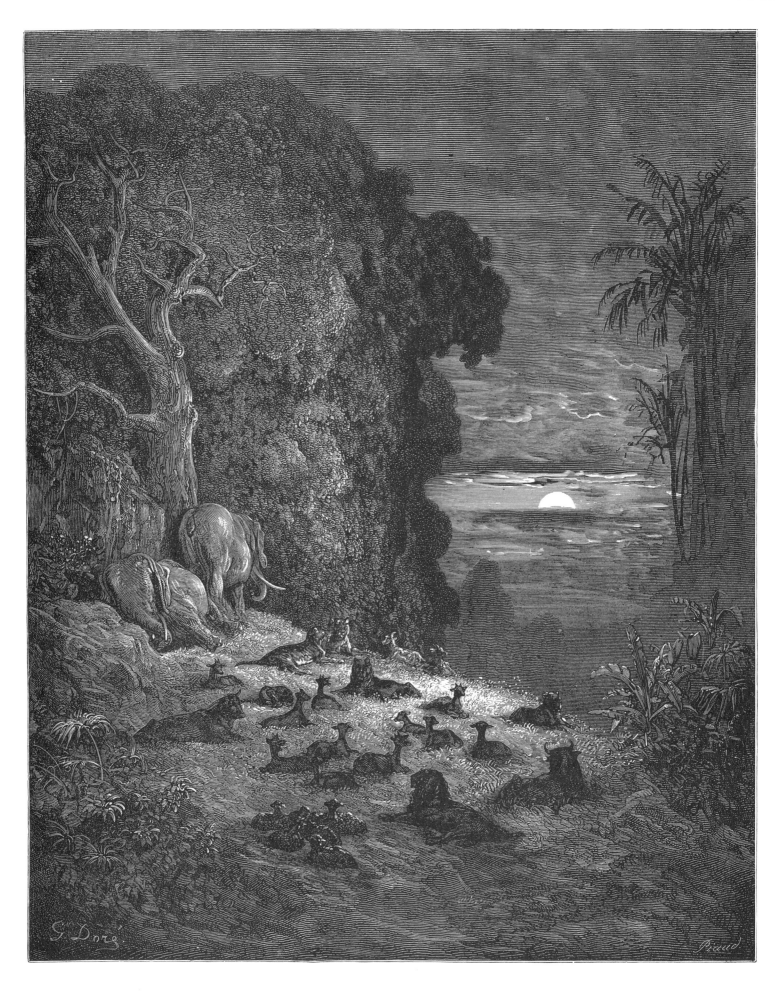

And now on earth the seventh / Evening arose in Eden (VII. 581, 582).

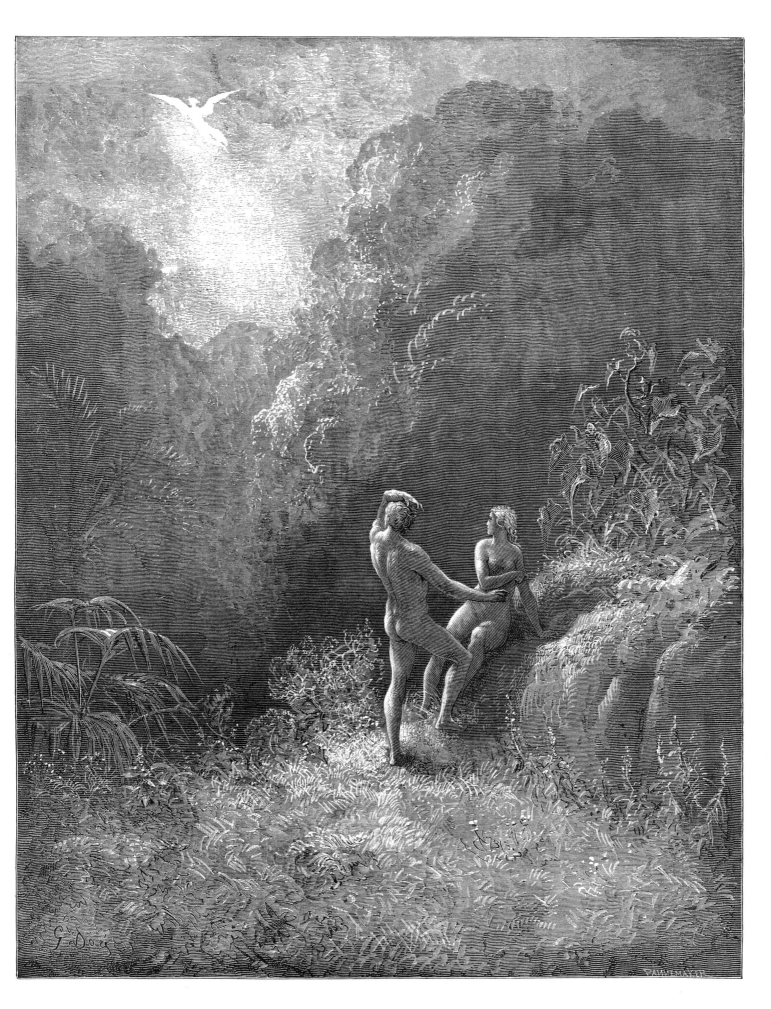

So parted they: the Angel up to heaven / From the thick shade, and Adam to his bower (VIII. 652, 653).

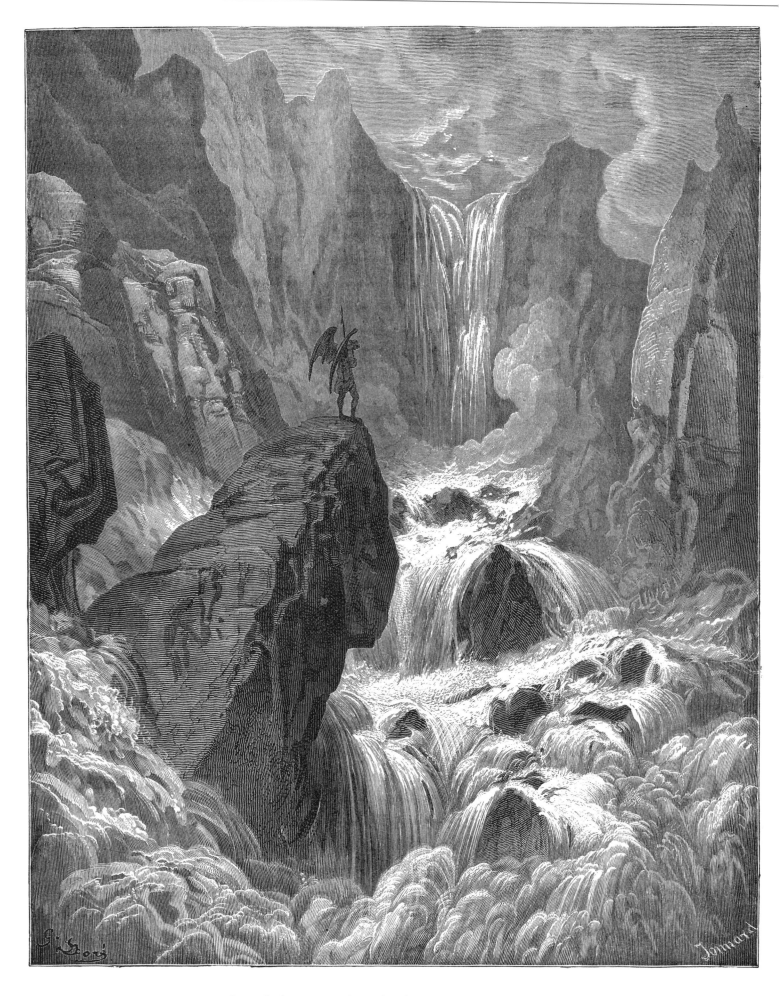

In with the river sunk, and with it rose, / Satan (IX. 74, 75).

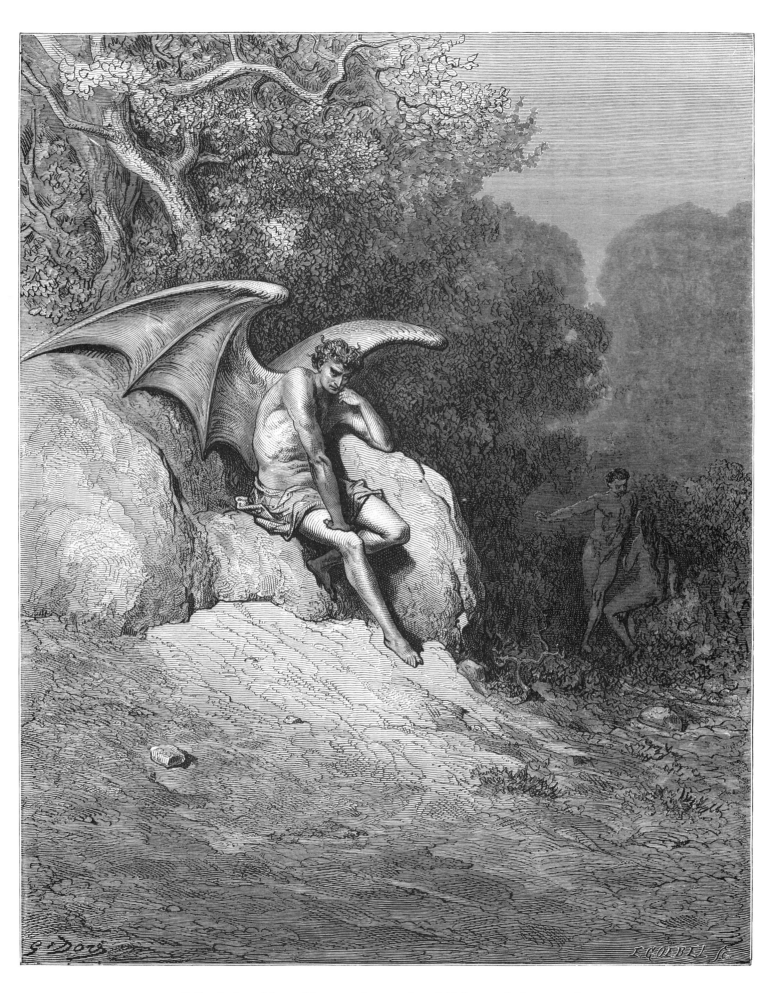

O Earth, how like to Heaven, if not preferred / More justly (IX. 99, 100).

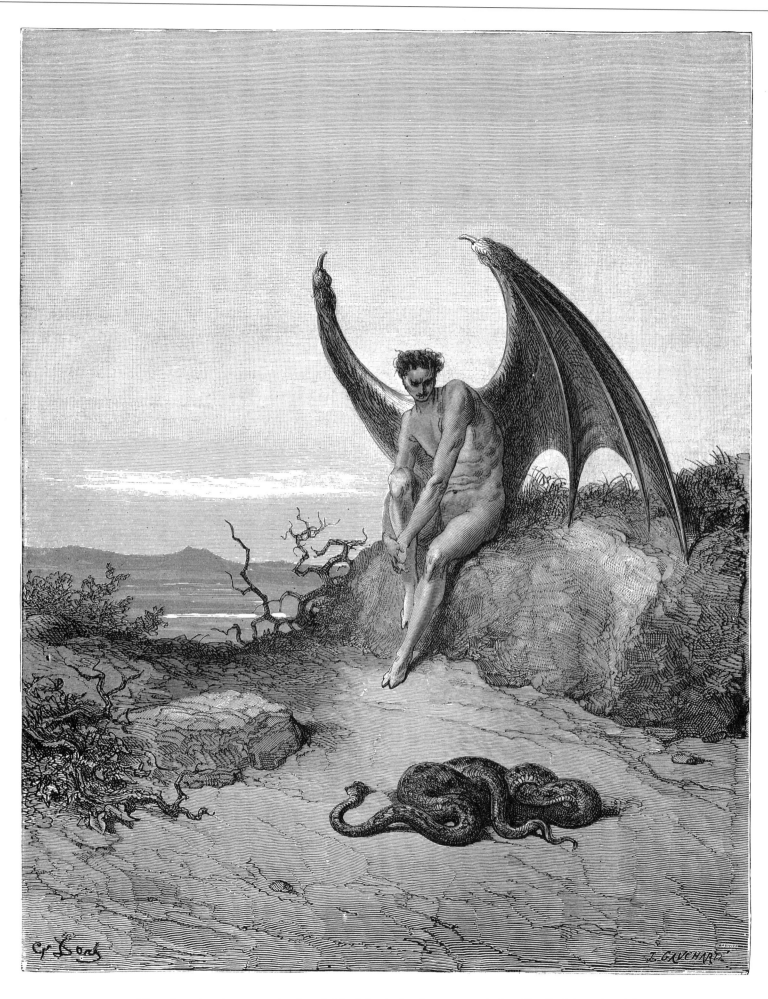

Him, fast sleeping, soon he found / In labyrinth of many a round, self-rolled (IX. 182, 183).

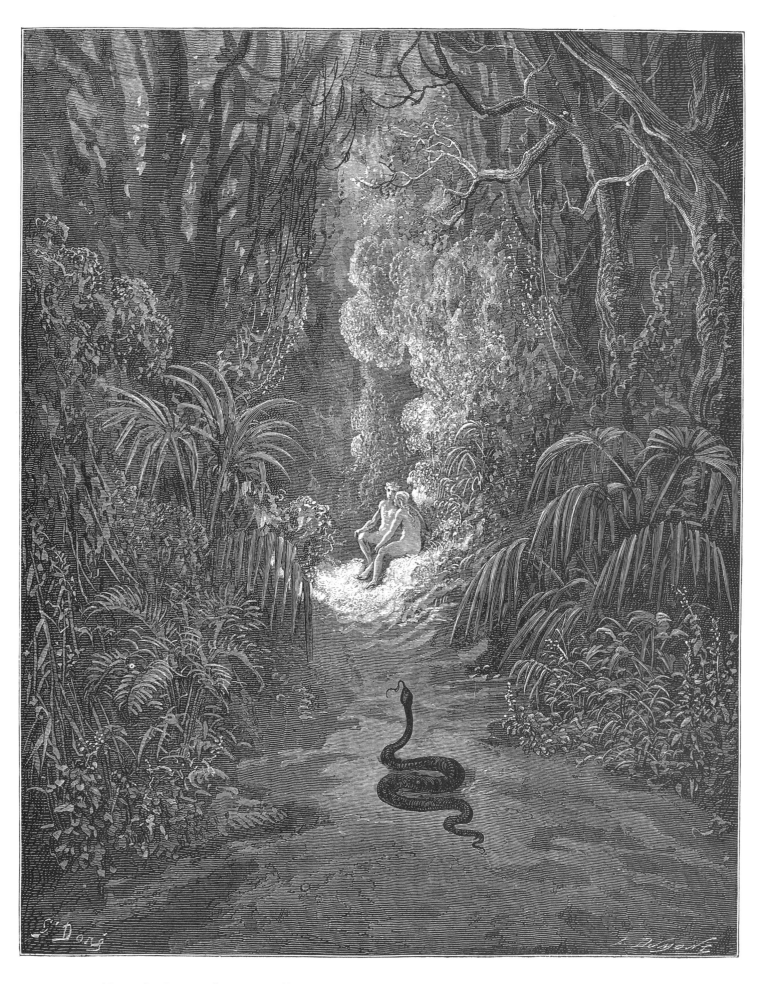

Nearer he drew, and many a walk traversed / Of stateliest covert, cedar, pine, or palm (IX. 434, 435).

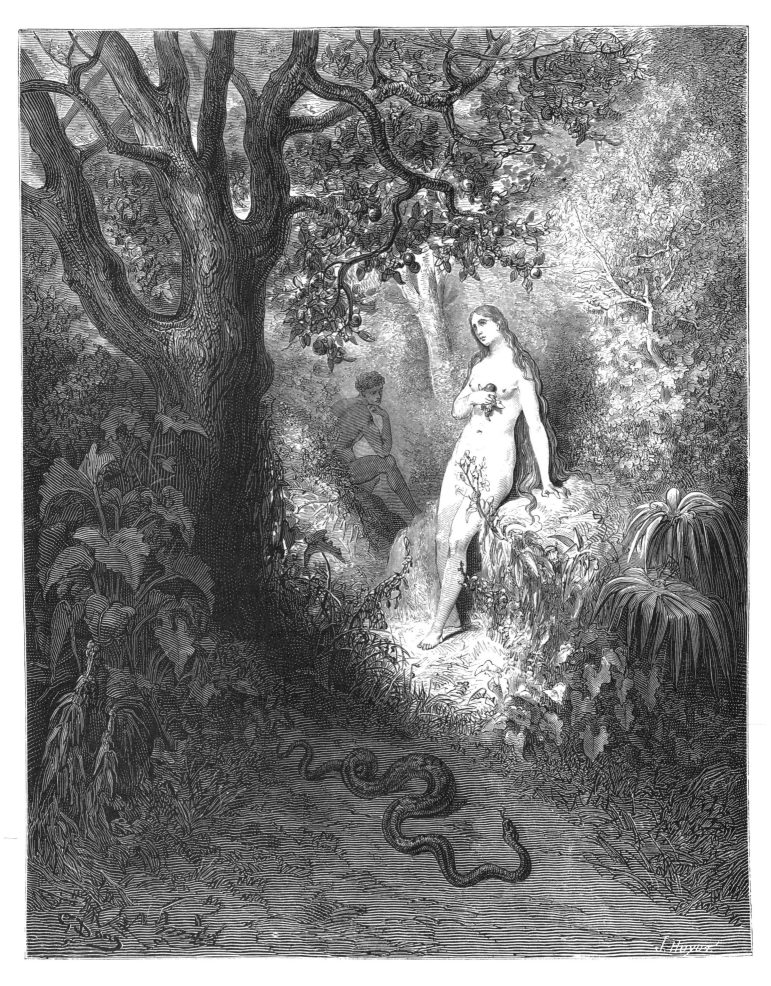

Back to the thicket slunk / The guilty serpent (IX. 784, 785).

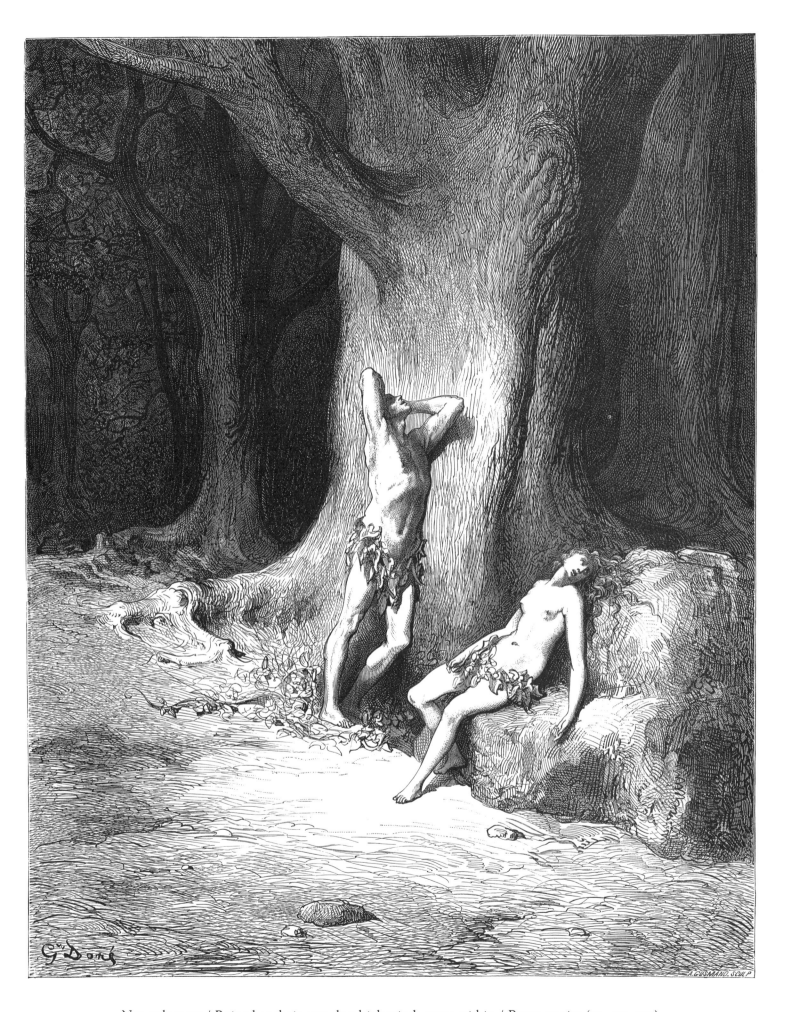

Nor only tears / Rained at their eyes, but high winds worse within / Began to rise (IX. 1121–1123).

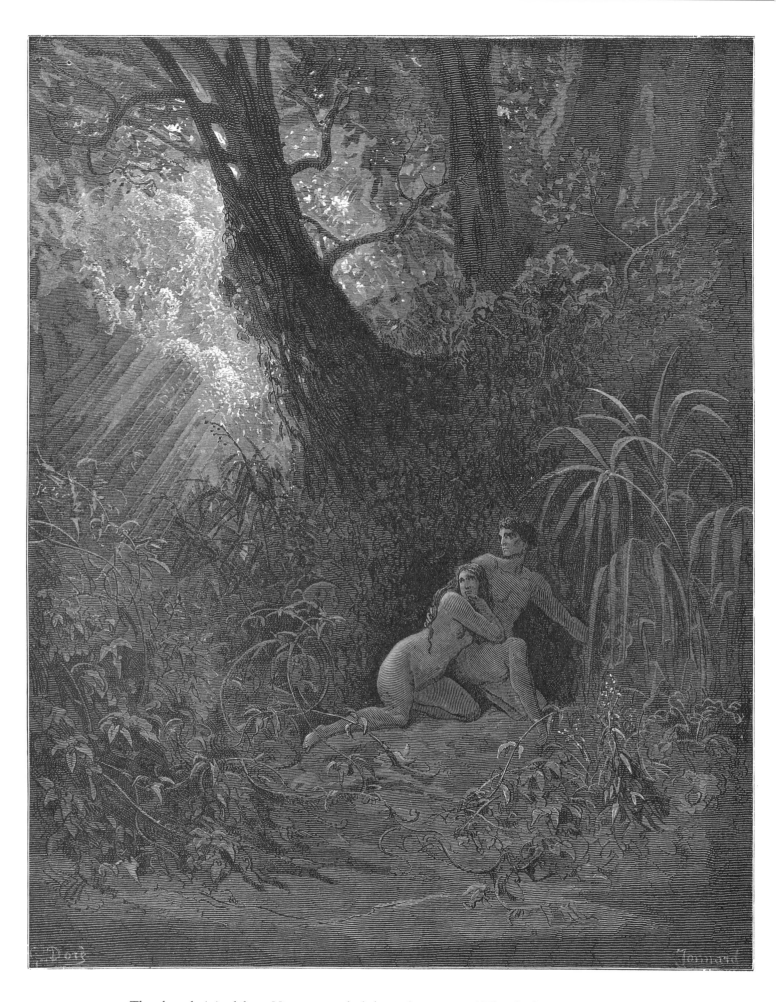

They heard, / And from His presence hid themselves among / The thickest trees (X. 99–101).

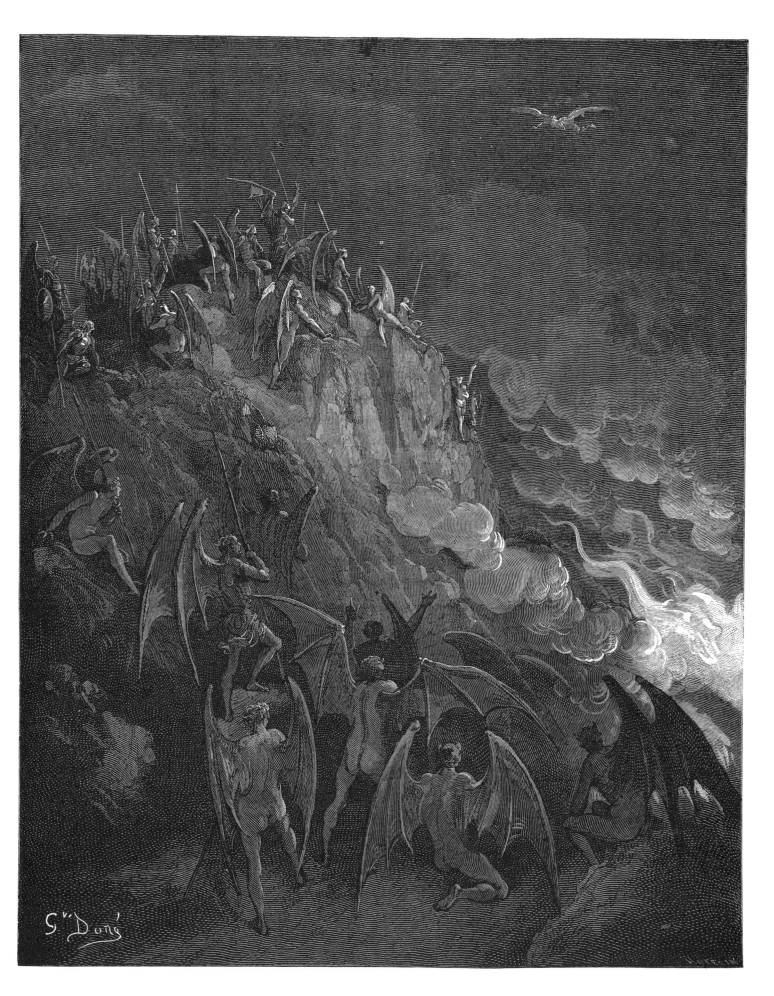

And now expecting / Each hour their great adventurer, from the search / Of foreign worlds (X. 439–441).

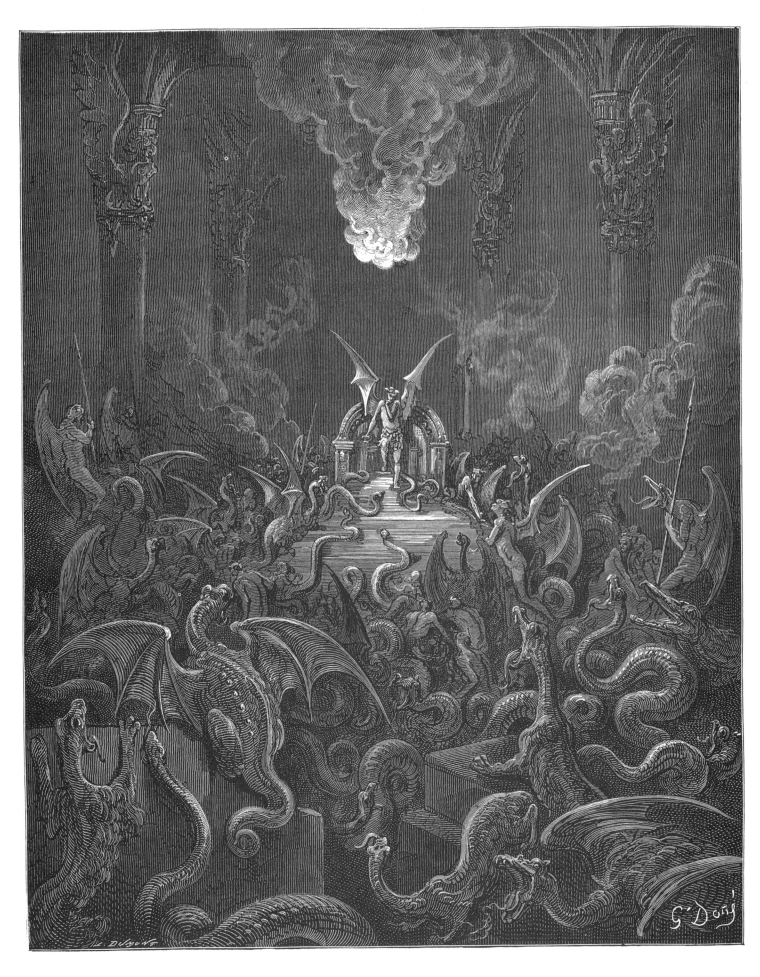

Dreadful was the din / Of hissing through the hall, thick-swarming now / With complicated monsters, head and tail (X. 521–523).

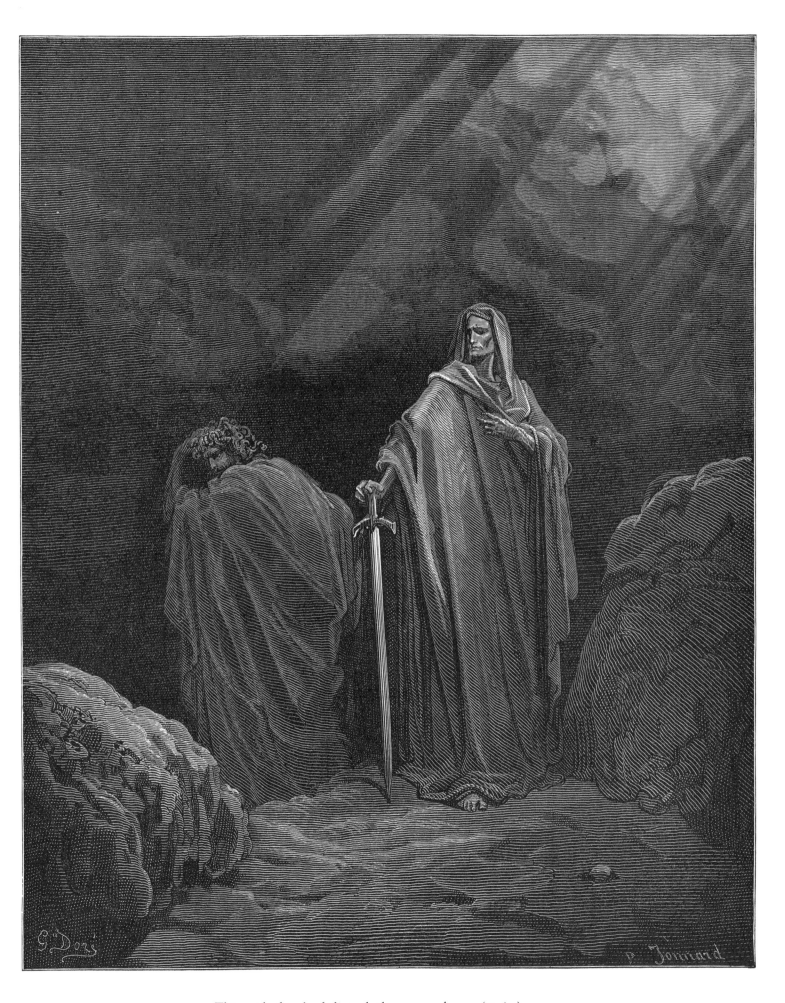

This said, they both betook them several ways (X. 610).

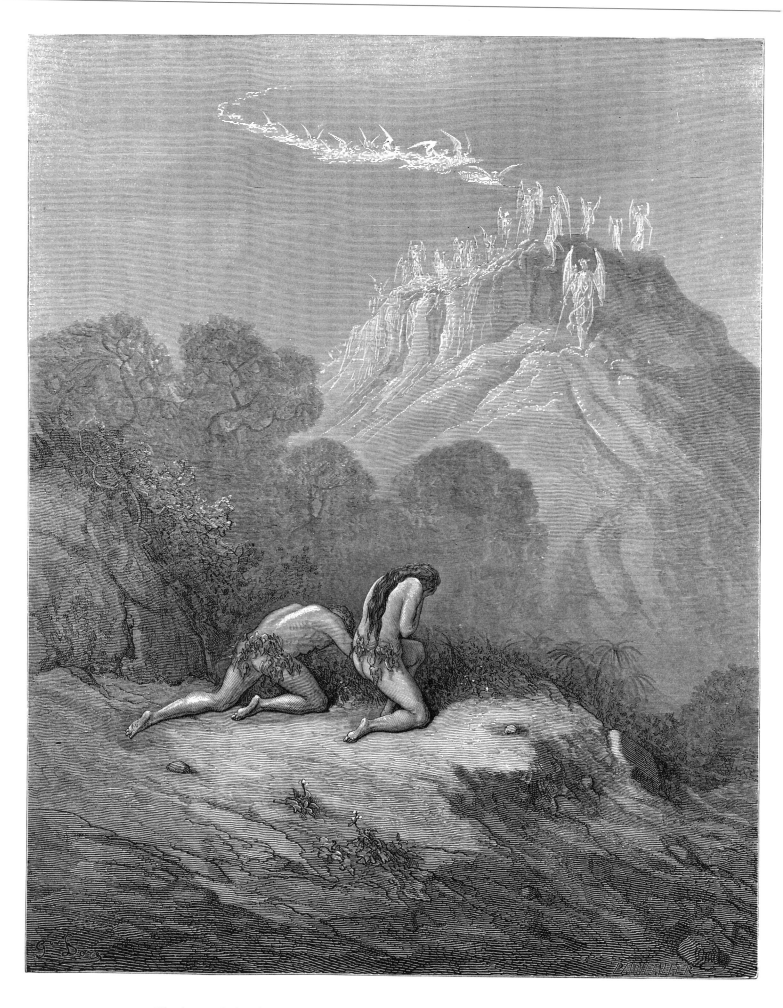

The heavenly bands / Down from a sky of jasper lighted now / In Paradise (XI. 208–210).

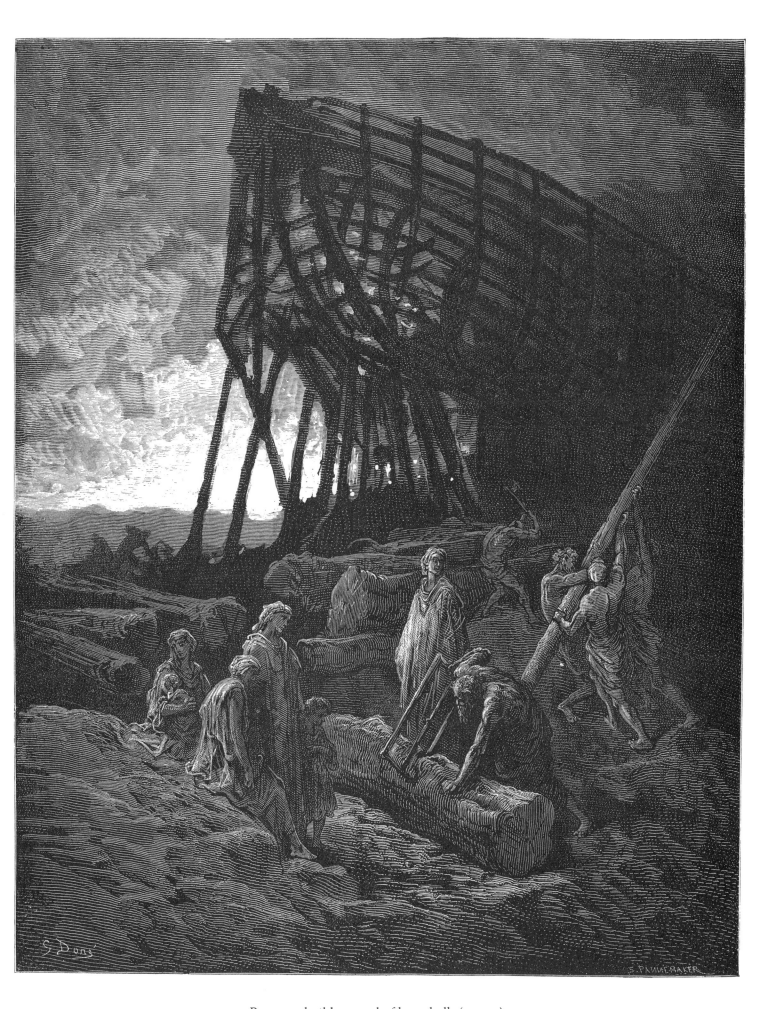

Began to build a vessel of huge bulk (XI. 729).

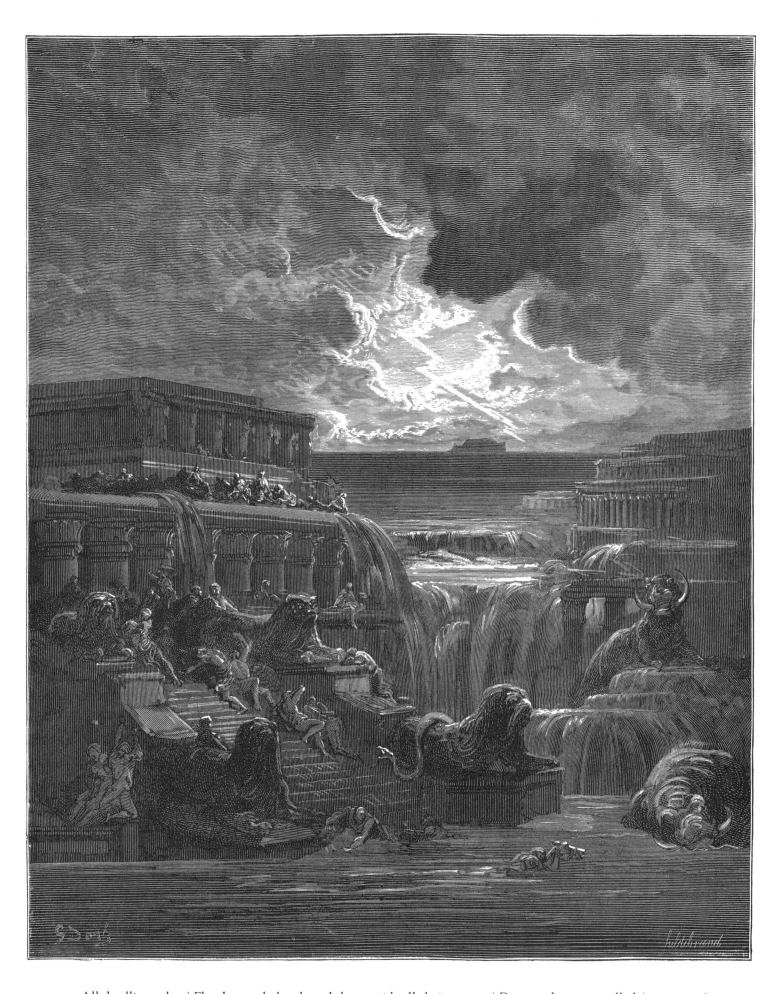

All dwellings else / Flood overwhelmed, and them, with all their pomp, / Deep under water rolled (XI. 747–749).

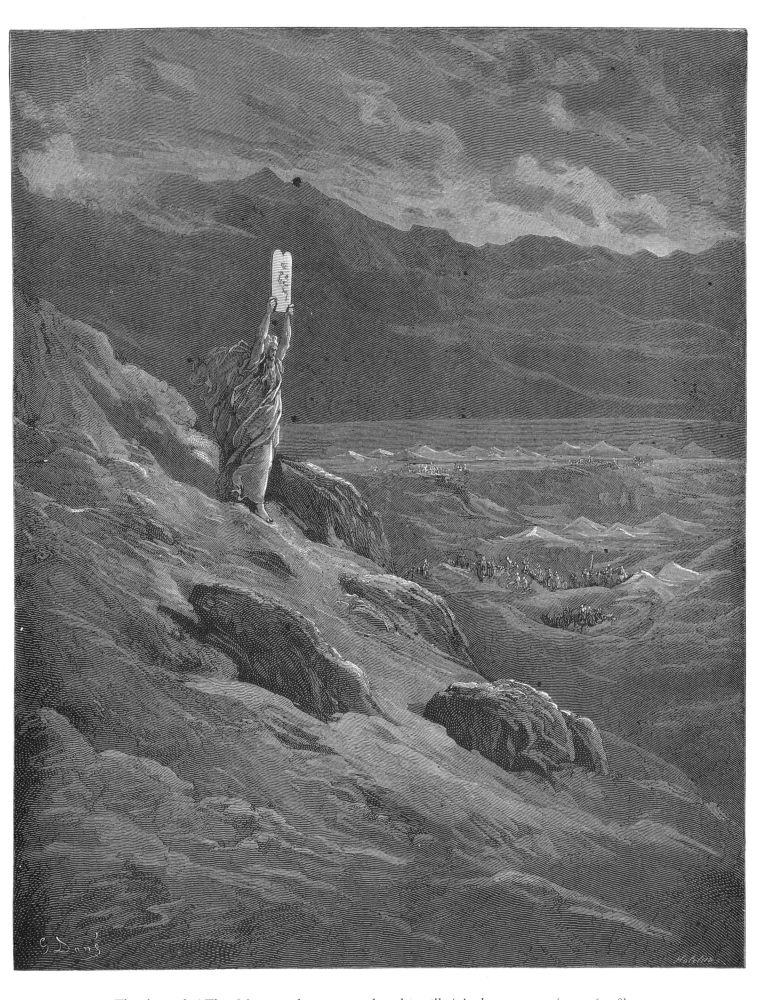

They beseech / That Moses might report to them his will, / And terror cease (XII. 236–238).

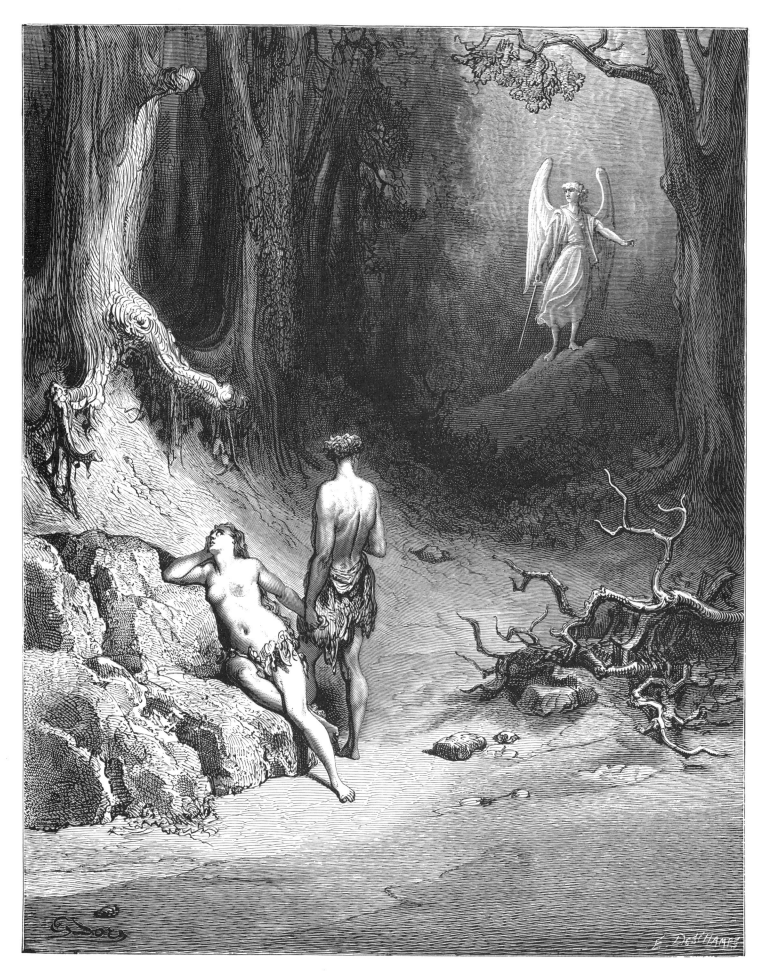

Some natural tears they dropt, but wiped them soon (XII. 645).